A JOURNEY OF A THOUSAND MILES

STARTS WITH A SINGLE STEP.

the Creative Photographer

CATHERINE ANDERSON

PIXIQ

An Imprint of Sterling Publishing Co., Inc.
New York

Editor: Haley Steinhardt

Book Design: Sandy Knight

Cover Design: Thom Gaines

Library of Congress Cataloging-in-Publication Data

10 9 8 7 6 5 4 3 2 1

First Edition

Published by Pixiq, an imprint of
Sterling Publishing Co., Inc.
387 Park Avenue South, New York, N.Y. 10016

Text © 2011 Catherine Anderson

Photography © 2011 Catherine Anderson unless otherwise specified

Distributed in Canada by Sterling Publishing,
c/o Canadian Manda Group, 165 Dufferin Street
Toronto, Ontario, Canada M6K 3H6

Distributed in the United Kingdom by GMC Distribution Services,
Castle Place, 166 High Street, Lewes, East Sussex, England BN7 1XU

Distributed in Australia by Capricorn Link (Australia) Pty Ltd.,
P.O. Box 704, Windsor, NSW 2756 Australia

If you have questions or comments about this book, please contact:

Pixiq
Lark Books
67 Broadway
Asheville, NC 28801
(828) 253-0467

Manufactured in Canada

ISBN 13: 978-1-60059-716-9

For information about custom editions, special sales, premium and corporate purchases,
please contact Sterling Special Sales Department at 800-805-5489 or specialsales@sterlingpub.com.

For information about desk and examination copies available to college and university professors,
requests must be submitted to academic@larkbooks.com. Our complete policy can be found at www.larkbooks.com.

For more about digital photography, visit www.pixiq.com.

for MY PRECIOUS FAMILY...

Your love, support, and encouragement make all the difference.

gratitude In the process of creating these projects and writing this book, I have realized that a book grows within its creator over many years. During that time, it is nourished and brought to life by encounters with many people. I am deeply grateful to everyone who has inspired my creative journey, whether through their words, their teaching, or their example. We are influenced by everything and everyone around us, and every encounter I have had has helped shape me and my vision of the world. I am so fortunate to have shared my journey with so many loving and generous souls.

A number of people have had a particularly meaningful role in the birth of this book:

Jan Phillips, who gave me the tools to believe in my own creativity; Ann Taylor, who asked me to teach a photography class, which turned out to be the first of many; Amy Royal who, day after day, listened patiently to my ideas for the book so that I could better understand my own thoughts; Elsa Safir, creative art sister, who is always willing to give me an honest opinion and fresh ideas; Marti Saltzman, for seeing the possibilities in my proposal and trusting me to deliver them; Haley Steinhardt, whose patient coaching of this first-time book author, and whose kind and careful editing, made this a joy- and fun-filled project; Sandy Knight, whose creative design work made this book come alive; Timothy Anderson, my 24-hour tech-support guy, who willingly fixes everything (and saves me hours of frustration) when technology gets the better of me; the members of the Photo Art Journals Yahoo! group for keeping me inspired and giving me a reason to keep stretching my creative wings; the members of my Muse group, who constantly encourage me to believe in myself. To you all, I offer my love and sincere gratitude for helping me to realize my dream.

4

THE EMOTION OF COLOR

66

5

PHOTOGRAPHIC INSIGHT

86

6

A WHOLE NEW PERSPECTIVE

102

7

IN SEARCH OF THE MYSTERY

112

8

ALL THINGS OLD AND BEAUTIFUL

120

9

PHOTOGRAPHY AS MEDITATION

132

FOREWORD

"The images on which we feed govern our lives," wrote Jungian psychoanalyst Marion Woodman. What we see impacts us deeply. Photographs have changed the world, started global movements, led to social change, ended wars, and revealed truth in ways words never could. The power in a photograph is its uncanny ability to speak from soul to soul. Its language is spiritual. Its mission is Joy, beauty, communion. When I share a photograph with you, I am revealing something that is deeper than words, something intimate, something significant about who I am and what I care about.

When you look at my images, you learn something new. You cannot say what it is you now know, but you are added to by my images. You will not be the same. And the same is true for me when I look at yours. I know something more… about you, perhaps, about the world, about myself. It's as if you offer a mirror to me that allows me to see more deeply into my own beauty and potential. That's why people often say, in the case of a house fire, they'd save their photographs first. They have a hold over us. They are our lives in a nutshell, the acorns of our oak-tree selves.

If someone were to ask me what is the best way to de-stress, I'd say, "Put a camera in your hands." Once we start looking at life through a camera lens, something calm and centering comes over us. We stop worrying about the past or the future as we immerse ourselves in the present moment, which is the only place we can be when we're seeing photographically. Photography heals us. Getting the image is healing. Doing something creative with the image is healing. And sharing our work is healing.

These pages are a guidebook for using photography in this way, and Catherine Anderson knows the terrain like the back of her hand. She opens door after door into exciting new possibilities in *The Creative Photographer,* and you will surprise yourself at the beauty you can create with the images you make. This book will not make you creative; you already are. You were born to create. This book will just release your fears, set free your potential, and offer you new ways to have fun with photography. Congratulations! You have in your hands a map to a whole new world.

Jan Phillips,
Author of *God Is at Eye Level: Photography as a Healing Art*

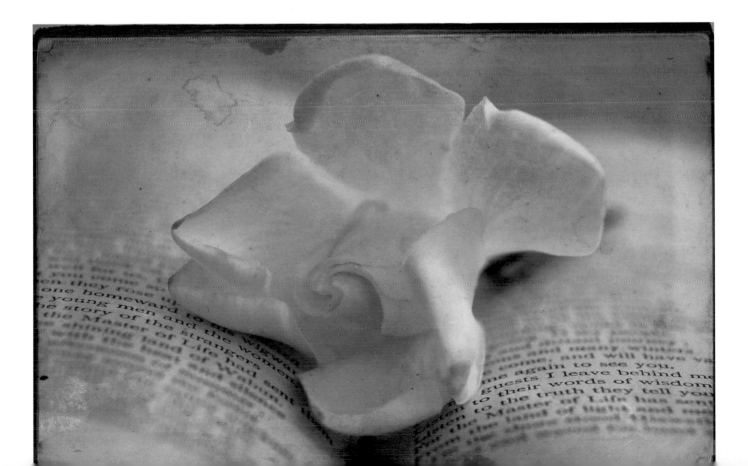

What we need to be taught is not art but to **believe** in ourselves, our imagination, our senses, and our hands, to free our bodies and spirits that we may live and work according to our visions.

—Florence Cane

YOU ARE AN ARTIST

I grew up believing that having the skills to be an artist was something with which you were born. If you could draw and paint and make a living from doing this, only then were you truly an artist. I always wished I had been one of those lucky ones. I made time in my life for creative pursuits—sewing, journaling, writing, and photography—but I didn't consider myself an artist. Then one day I discovered these words by writer and photographer Jan Phillips:

> To be an artist it is not necessary to make a living from our creations. Nor is it necessary to have work hanging in fine museums or the praise of critics … To be an artist it is necessary to live with our eyes wide open, to breathe in the colors of mountain and sky, to know the sound of leaves rustling, the smell of snow, the texture of bark … To be an artist is to notice every beautiful and tragic thing, to cry freely, to collect experience and shape it into forms that others can share."

These words changed my life. They made me realize that the limited definition of "artist" that I had grown up with was wrong. These words reminded me that every one of us is an artist, and when we express ourselves in our own unique way, we allow our artist self to come out and play. Instead of judging my limited skills, I was now able to give myself permission to play and practice with my camera. I created simply for the joy it gave me. I allowed myself to enjoy the process and let go of the need to create something that others would approve of. If I liked what I did, and if I had fun making it, it was worth doing.

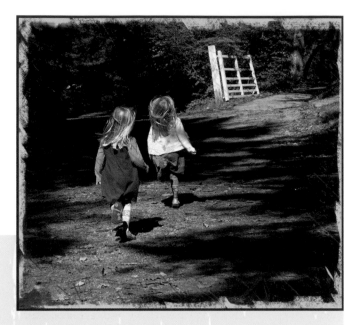

TAKE TIME TO REFLECT

There is magic in the process of making a photograph. For me, it is a way to express beauty, rawness, age, time, and other emotions and feelings that I can't put into words. It is a way of expressing who I am. In taking a photograph, you can "capture" a moment in time in a way that shows how you saw it, and then you can share that unique vision with others. It almost feels like bottling time. When I take a photograph that speaks to me on this deep level, I can only describe it as a spiritual experience.

The creative process of photography allows me to be fully present, to see the beauty that surrounds me, and to feel gratitude for the amazing world I live in. It allows me to recognize the miraculous in everyday moments. These are considerable gifts.

I also believe that photography has the potential to help us work through some of life's tough times in the same way that painting or writing or other creative work does. Photography is like visual journaling, and what we are drawn to photograph can speak to us in a symbolic way. We all see the same thing, but we see it differently, and our images show others how we see the world. They also remind us how to tune into our own perception. Our intuition recognizes what about a subject or scene is calling us to photograph it even if our minds don't. Photographs are merely the surface of a deeper expression. What do you want to express? Trust yourself. You have something meaningful to say.

There is no competition. There is no rush. Use your camera as a way to slow down and see with your eyes wide open, to see with your heart. You will start to see differently and more deeply. Photography is a patient teacher, allowing us to change our pace.

A true photograph need not be explained, nor can it be contained in words. —Ansel Adams

BEYOND TECHNICALITIES

I'm interested in taking photographs that speak to others, photographs that express how I see what is in front of me, photographs that show you how I feel when I see something beautiful or something sad. I want the viewer to feel a connection when they see my photographs. I want my images to touch people on a soul level. This interests me more than the technical aspects of using a camera.

I first became a photographer when I purchased a photography franchise that specialized in youth sports photography. Interestingly, one of the things that attracted me to that initial purchase was that I didn't need to know anything about how to use a camera; part of the arrangement with the franchise was that we would be taught everything we needed to know about taking photographs.

I had never owned a manual 35mm film camera and had no idea how one worked, but I was keen to learn. The only instructions I received were to set the camera on f/8, 1/125 second, and if it is cloudy change to f/5.6. Amazingly enough, I took photographs for almost a year with just this knowledge, and they all turned out! I then decided it was time to find out why I set the camera at f/8 with a shutter speed of 1/125.

I began to search out classes and soon discovered that there was so much more to photography. It had seemed so simple, but with my new knowledge I was almost frightened of my camera as there seemed so much I could do wrong. This was before the days of affordable professional cameras that allowed you to put your camera into an automatic exposure mode, and long before the days of digital cameras, so I couldn't check my image to make sure I had exposed it well.

Even then, however, my need to express myself was more important than my fear of the technical aspects of photography, and so I persevered. Sometimes I was frustrated, but I always returned to my camera as I knew that it was my tool to understanding and expressing who I was. Some people pick up technical information quickly and easily, but if you are like me and technical stuff gives you a headache, don't be ashamed to just set your camera to one of its autoexposure modes and let yourself concentrate on making images. The technical aspects will become easier to learn as you need and want to improve what you are doing through your camera lens. It is easier to remember something when you are actually using it in a practical way.

PHOTOGRAPHY AS A CREATIVE PRACTICE

The most important skills to learn in undertaking photography as a creative practice are how to play and how to experiment. Strangely enough, we forget how to play as we grow older. Many of us also hold the belief that we need to get things right the first time. Quite the contrary, I believe that the best way to learn is to make mistakes, and it is also a wonderful way of finding new ways to do things. In fact, mistakes are often more useful than successes, and are far more interesting than repeating things you've already done many times.

Push yourself to try new things whenever you can. It keeps you growing creatively. Remember that there is no right or wrong way to be creative; there is only the way that allows you to express who you are. All original art begins with experimentation and often develops through mistakes made and asking the question, "What if…?"

The essential part of creating is in the process rather than the final product. Look at children and see how they learn. Your creative path is a unique one and my hope is that, through the exercises and discussions in this book, you will be inspired to take your camera in hand and let it be your constant, playful, and generous companion. Good images are those made with your heart and your eye working together to create a visual language that is uniquely your own.

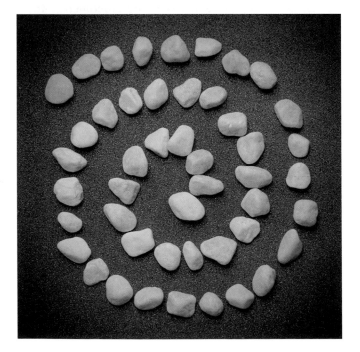

The process of discovery involved in creating something new appears to be one of the most enjoyable activities any human can be involved in.
—Mihaly Csikzentimihalyi

NURTURING CREATIVITY

It has always been important to me to spend some part of my day in creative activity. The process of creating seems to balance and calm me. My first career, which spanned fourteen years, was as an attorney practicing property law in South Africa. After a day working with mortgages and deeds, followed by time with my family, I still had to carve out at least half an hour to "play" in my sewing room in order to feel relaxed and centered. It didn't matter if it was just touching the fabrics, arranging the fabrics in color combinations for a quilt, or actually sewing on my machine—I needed a connection with my inner creative artist.

I think this daily connection to your creative work is how you grow into an artist. To be a good photographer, as to be a good pianist, you need to practice. I have found that the more I've used my camera and my eye, the more they have become trusted friends who help my photography improve. There is always more to learn and to see, and knowing this can encourage you to grow creatively throughout your life.

Metaphorically speaking, creativity is like a campfire. You must tend to it. With careful nurturing, the flames will burn brighter and soar higher than you can ever imagine, providing both warmth and illumination. —Mark S. Johnson

CREATIVE EXERCISES

In this book, you will find three kinds of creative activities: camera-based projects, computer projects, and art-table projects. I encourage you to get together with a group of like-minded friends and do these exercises together. Doing them in a community encourages you to keep improving your skills. You could even start a blog and post your creative adventures for others to be inspired.

With Your Camera
In these sections, I will suggest practices to improve your photography and connect to your inner visual artist. Included are ways to make mistakes and learn from them, as well as steps to help you get to know your camera and the world around you. These projects encourage you to play and have fun, to start seeing again with the wonder of a child. Let these activities inspire your photography and support your own unique, creative process.

And remember, photographing with a digital camera gives you the opportunity to review your images as you take them to see what is working and what is not. This, combined with the fact that you need not have any concern about the cost of each image, means you have no reason not to take creative risks and experiment with new techniques. Take your camera with you everywhere you go!

At Your Computer
Using Photoshop Elements, I will show you some basic ways to improve your photographs with image-processing software, as well as illustrate how it can give you endless possibilities for playing creatively with your images. These projects emphasize the use of imaging software as a creative tool to achieve different looks and artistic effects. I hope to inspire you to start experimenting with image processing without feeling overwhelmed by it.

At Your Art Table
These are projects that might get your hands dirty. They use paper, glue, and sometimes paint. I will show you how to fold and make books, cards, and an array of other photo-based items that will allow you to exercise your inner creative muse.

CAMERA BASICS

One of my favorite photographers is Gertrude Kasebier. Gertrude started learning how to photograph when she was 36 and describes what she had to do in the mid 1890s to develop her photographs: "I had no conveniences for work, no darkroom, no running water in the house. Owing to the long twilight, I could not begin developing before ten o'clock. I had to carry my wet plates down to the river Brie to be washed. My way was through a winding path, with a tangle of overhanging branches, through a darkness so dense I could not see a step before me. It was often two o'clock in the morning, or almost dawn, when I had finished." I am grateful to live in an age of digital photography. It would require extreme dedication to your art to go to the river in the middle of the night so that you could develop your photographs!

I'd like you to see how your camera can be a great tool to express who you are. To that end, although this is not a book about how to use your digital camera, I will briefly cover some basic information about how cameras operate. Even though I know my camera relatively well, I always carry the instruction manual with me in my camera bag, as I never know when I may need to refer to it. If you are still getting to know your camera, I would suggest that one of the first things you do is sit with your instruction book open to the page that shows a diagram of the camera. Follow the page references so that you can see what each dial and button is for. Technical manuals can be a little daunting, but it is useful to know what your camera can and can't do. Repeat this exercise from time to time because, as your creative abilities grow, so will your need to push the boundaries with your camera. Don't be afraid of the technical side, but don't think that you need to learn it all before you begin. You can learn it along the way.

If you are new to photography, I suggest that you start by putting your camera on the Auto or Program (or similarly named) setting. This allows your camera to make all the exposure decisions for you and you can just focus on composing the photograph. This works perfectly on sunny bright days, and is a great way to start getting a feel for your camera. When you feel ready to start learning more about your camera, get out your instruction manual and look up information about the topics outlined on the following few pages. Note that some of the more basic cameras may not have all of these options.

(hint) Don't rush out and buy a new camera. Learn all you can with your existing camera first. Your creative eye is the most important tool you have. A better camera will not make you a better photographer. Learn to see first.

Shooting Modes

When set to a fully automatic mode, the camera sets everything for you: aperture, shutter speed, ISO, white balance, focusing mode, and flash. Some cameras have what is called Program mode, which automates aperture and shutter speed but lets you decide the rest, including whether you want to use the flash. If you have this mode on your camera, it is preferable to the fully automatic mode where there will be times when the camera decides to use the flash and you may not want it.

Another mode to consider experimenting with (if your camera offers it) is Aperture Priority mode (often signified by A or Av on the camera's Mode dial). In this mode, you decide on the aperture you want (how wide you want the opening in the lens to be), which determines the depth of field for your image (see page 17 for more details). The camera chooses the correct shutter speed to match the aperture you select.

In Shutter Priority mode (usually signified by S or Tv, which stands for time value), you decide the shutter speed and the camera automatically selects the correct aperture to match. Shutter speed refers to the amount of time it takes for the camera's shutter to open and close to allow light to expose an image on the sensor. This mode is good for when you want to freeze motion, or create creative motion blur. A slow shutter speed (anything below 1/30 second) will blur motion, and a fast shutter speed (such as 1/125 second or above) will freeze motion.

If talk of apertures and shutter speeds is scaring you, ignore this section and leave your camera on Auto or Program mode for the moment. Come back here when you want to learn more about this technical stuff. That said, even if you do want to use one of the fully automatic shooting modes, you should still make sure that you are shooting at the highest resolution possible, so be sure to read the resolution section on page 17.

It doesn't matter if you don't have a sophisticated camera, if you have never studied photography, if the photographs you take are far from professional. What matters is that something intimate and precious and sacred is being brought to life and shared with another.
—Jan Phillips

Depth of Field

Depth of field is the term used to describe the area of an image that is in sharp focus. An image with shallow depth of field has only a small area that is in sharp focus. The size of the aperture opening in the lens (i.e., the f/stop) determines the degree of depth of field. If you want everything in your photograph to be in sharp focus, use a small aperture such as f/8, f/11, or higher. If you want to selectively focus on your subject and have the background blurred, use a wider aperture setting such as f/4 or f/5.6.

Resolution Settings

This is important. Set your camera to the highest possible resolution and quality settings. You will fit fewer images on your memory card, but if you have a photograph that you want to enlarge, or one you wish to crop, having your camera set to record the highest-quality image it is capable of is essential. You can always reduce the resolution of an image, but you can't increase it.

Memory Cards

Your digital photographs are stored in your camera on a memory card. Your camera instruction manual will tell you what kind of memory card you need for your particular camera, as there are a number of different kinds. Memory cards also come in different memory capacity sizes. I recommend using cards between 1GB and 8GB (GB stands for gigabyte). The card that comes with your camera will generally only be about 32MB in size (32 megabytes), which only give you room to store maybe 10–12 images, so you will want to purchase a larger-capacity card. The higher the resolution and quality of each image, the less will fit on a given memory card.

You should format your card the first time that you insert it into your camera, and frequently thereafter. This will help keep your card from malfunctioning, causing you to lose your images. Check your camera's instruction manual for directions on how to format a memory card.

To Flash or Not to Flash

I use my camera flash as little as possible, but there are times when it is unavoidable. If you do have to use on-camera flash and you are shooting with a DSLR and a hot-shoe-mounted flash unit, you can try and bounce it off of a white ceiling if possible. With point-and-shoot cameras, or even DSLRs with a built-in flash, you can tape a piece of tissue over the flash to tone it down. Flash is often not flattering, as it flattens the image.

You may occasionally need to use your flash as a fill light, however, such as outdoors when the sun is directly overhead and you need to avoid dark shadows on faces. Also, if your subject is backlit and standing in shadow, even the fully automatic exposure mode will often not activate the flash, instead exposing for the brighter backlight. Without fill flash, your main subject standing in shadow will likely be too dark in the final image. The automatic flash only works when the camera doesn't think there is enough light, so you will need to use a fill flash for these situations.

ISO

The higher the ISO number, the more sensitively your camera responds to light. On a sunny day, the standard ISO 100 works well. If you are photographing in low light or indoors and don't want to use a flash or a tripod, you might want to increase the ISO to 800 or more, depending on your camera. At higher ISO settings, some cameras will produce grainy or "noisy" images. Experiment with the higher ISO settings if your camera has this capability. Even if the images are grainy, you might like this effect. And, if the images are fairly noise-free, using the higher ISO settings in low light is a good way to avoid using a flash.

The virtue of the camera is not the power it has to transform the photographer into an artist, but the impulse it gives him to keep on looking—and looking.
—Brooks Atkinson

White Balance

As a beginner, I suggest setting your camera to its Auto white balance mode, which is probably where it is set already if you have not changed it from the factory default. The color of light changes throughout the day and is different under artificial indoor lighting. Automatic white balance will usually control these color shifts.

If you are interested in finding out how white balance works, the easiest way to do this is to take the same photograph with your camera set on each of the different white balance settings (such as sunny, cloudy, incandescent, and fluorescent) and observe the different ways that the colors in the scene are recorded. There is a whole science around color temperature, but you don't need to understand it to use it to your advantage. Once you see how each setting renders the light (your image might even look blue or magenta or green), you can even consider setting the "wrong" white balance to purposefully create a certain colorcast in your images. However, I don't recommend this when you have people in your image for obvious reasons!

Deleting Photos

When it comes to deleting photos in-camera, my advice is to wait and review your images on a computer monitor instead before deleting them. The small screen on your camera often does not allow you to make an accurate decision about a photograph. So unless you are 110% sure that the frame is a miss, don't bother with in-camera deletion.

Tripod

You can definitely get sharper images using a tripod, especially in low-light situations. But sometimes having to carry a tripod can make photography feel more like a chore than like having fun. Generally, I don't shoot with a tripod unless I am at home or on a road trip where I can leave it in the car when I want to. I like to be as unencumbered as possible when taking photographs. There are plenty of small, tabletop tripods on the market, but I find that, most times, a wall, a tree, or a car—or the table itself if you're indoors—can work just as well to stabilize your camera. Stabilization is important if you are photographing something that has to be in sharp focus, or when using a slow shutter speed when your intention is not to create motion blur.

IMAGE-PROCESSING BASICS

After my camera, my image-processing program is the other tool that allows me to take my photography to a more creative and artistic level. When I first learned Photoshop Elements, it opened up a whole new world for me. It became my digital darkroom, allowing me to improve and expand the photographs I had taken without spending hours developing and printing my images.

All the computer project steps outlined in this book reference Photoshop Elements, but this is only one of the many photo-editing software packages that are available. Most software manufacturers offer a free trial download, so experiment with what's out there and see what works best for you. The instructions for other programs may vary from what I state here, but once you know your way around your preferred program, you should be able to adapt the instructions in this book to your tools.

Be patient with yourself as you learn your way around image-processing software. If things don't work as you want them to, don't get frustrated; treat it as a problem-solving game. Remember, mistakes are the pathway to new discoveries. When I first learned Photoshop, I would create wonderful effects but not have the vaguest idea how I arrived at them, so I could never replicate them. It took me a while to become comfortable with the program, and I'm still learning what it can do, as its applications are virtually limitless.

The easiest way to learn the basics of a particular software program is to watch video tutorials or take a class. Adobe, for example, provides tutorials at tv.adobe.com. All you need to do is select the product you are using and you will have access to a library of videos covering all aspects of the software. That said, I would still like to take a moment to cover some of the most basic Photoshop actions that I use throughout this book. The projects we will explore in the chapters ahead may capture your artistic vision even better if you take the time to enhance the images you are using to build your artwork. So, let's cover the basic steps for improving a photograph.

{ THE PRACTICE OF PHOTOGRAPHY }

Steps for Improving Your Images

It is very seldom that a photograph we make cannot be improved using some basic image-processing tools. They can allow us to adjust the exposure of an image so that the color, brightness, and contrast are more in tune with what our eyes actually saw. Post-processing can save a washed-out-looking image, or one taken on a gray day (which often makes colors and contrast look flat in photographs). It can darken the blacks and brighten the colors. It can also allow us to crop the image and resize it to use in a particular project where the size of the image is important.

1. Open Your Image: Open an image in Photoshop Elements by going to File > Open and selecting an image from the appropriate file folder.

2. Make a Duplicate Layer: The first thing I always do is create a duplicate layer of my photograph so that any changes I make are not made on my original file. To do this, go to Layer > Duplicate Layer and click OK. This creates what is called a Background copy, the layer on which you will make all your adjustments.

3. Adjust Levels: The Levels tool allows you to adjust your image for the best exposure contrast. If you do nothing else to improve your image, at least check out this one tool.

To access Levels, go to Enhance > Adjust Lighting > Levels. Look at the graph, known as a histogram, in the Levels window. The histogram is a graph of the light and dark tones in the image. If there are gaps between the edges of the histogram and the edges of the image data, click and drag the white and black triangle sliders to meet the edges of the histogram. If you move the center triangle slider you can lighten the middle range of the image. Play with these sliders. See what happens to your photograph as you move them up and down. What is the look you like best? Click the eye symbol next to your Background layer to make that adjustment layer invisible so that you can compare your original image with your adjusted image.

4. Adjust Brightness/Contrast: Next, go to Enhance > Adjust Lighting > Brightness/Contrast and play with these sliders to see if you can improve your image. You can also do the same with Enhance > Adjust Lighting > Adjust Shadows/Highlights. There is no perfect equation. Only you can determine what looks best for your particular image.

5. Other Enhancements: This is when to apply all the fancy effects and adjustments that we will go over in detail in the projects in this book. These extra steps are optional, but they are certainly worth exploring.

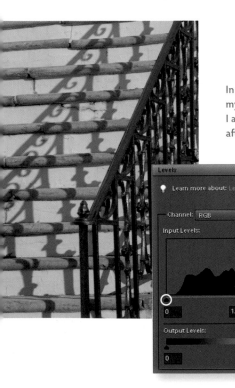

In this example, you can see how my original image looked before I applied Levels (left), and then after (right).

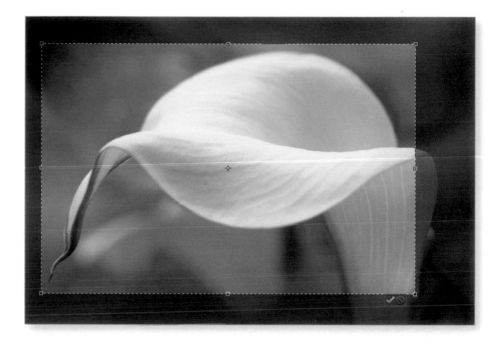

Here is an example of what the Crop Tool overlay box looks like on an image before cropping.

6. Size and Crop Your Image: Before taking this step, bear in mind what the intended use for the final image is. Do you want to make a framed print of it? Or a poster? Will you only be displaying it on the Internet? If you don't know for sure, it is best to save the image at the same size as the original image file so that you can keep your options open. Always save your enhanced image under a new name so that you can revert to your original image if need be.

You can size your image either by going to Image > Resize > Image Size or simply by entering the desired size and resolution info into the appropriate boxes when using the Crop tool. When using Image > Resize > Image Size, the first choice you will make is whether you want to work with your document in inches or centimeters. Then, set the resolution. I always set mine to 300 ppi (pixels per inch). This resolution gives a good print quality. However, if you only plan to use the image on the Internet, you can go down to 72 ppi to save on upload time. Don't select this low resolution, though, unless you know for certain that you don't want to print, and remember to save it under a new name so it doesn't override your original image.

Next, make sure the Scale Styles, Constrain Proportions, and Resample Image boxes at the bottom of the Image Resize window are checked. That way, you can change the width or height of the image to match your requirements and the program will automatically change the corresponding measurement to stay true to the original

image proportions. If you need or want a specific size or unique aspect ratio that is different from the current proportions and you don't wish to distort your image, you will need to use the Crop tool. If you need to distort your image, you can uncheck the Constrain Proportions box in the Image Size window and change both height and width measurements to fit your needs.

To use the Crop tool to size your image, go to Image > Crop. At the top of your screen, you will be given the following options to fill in: aspect ratio, width, height, and resolution. Set the resolution first. As I mentioned, I always set the resolution at 300 ppi if I plan to print the photograph.

If I want to use the photograph on the Internet, I set the resolution to 72 ppi, making sure to save this low-resolution version as a copy so as not to overwrite the original image. Under the Aspect Ratio dropdown menu, you will find some preset sizes that you may want to use. If none of these are right for your project, set your own width and height in the relevant boxes. A grayed-out box will appear over your image showing the new size you have selected. You can move this box to any part of the image and can also change the area of the photograph contained within it by clicking and holding one of the corners and moving the box inwards or outwards. Once you are happy with your selection, click the green checkmark at the bottom, right-hand corner of the crop box to accept the new cropped image dimensions.

Cropping is particularly important if you plan to print 4 x 6-inch (A6) photos, for example, and your camera's sensor does not produce images with a 3:2 aspect ratio, as many do not. Some online labs give you the option of printing 4 x 5.33-inch (10.2 x 13.6 cm) photos, but others will automatically cut off the top and bottom of your image which can be a problem. Using the Crop tool, you can also change a vertical photo (also known as a portrait orientation) to a horizontal photo (also known as a landscape orientation). You can also create panoramic or square photo shapes. However, remember that if you crop only a small portion of the image to use, you will have many less pixels to work with, and may have to print a smaller photograph to maintain decent sharpness. This is one good reason to try and get your framing as close as possible to what you want it to be in-camera when you make the photograph.

Finally, you can also use the Crop tool to rotate your images slightly. This is useful for getting horizons straight. Hold your cursor just outside the crop lines once the grayed-out box is in place and you will see a two-sided arrow. Click and hold this, then move it in either direction to see the crop box change its orientation over the image area.

7. Save Your Image: I recommend saving your image as a Photoshop file (PSD) or TIFF file (with no layer compression) first. These formats will save all your layers so you can come back and make adjustments to your photograph at any time. If you plan to print the image, you should also save it as a JPEG. Once in JPEG form, you will not be able to make further adjustments to the existing layers in your image; any adjustments would have to be made in a new layer.

MAKING THE MOST OF PRINTING

Personally, I prefer to have my photographs printed at a photo lab rather than on my personal home printer. I like the durability and affordability of lab prints and the fact that I don't have to spend time printing my images. However, it is possible to use your personal home printer for this purpose, as all printer manufacturers also provide their form of photographic paper. If you go this route, remember that inkjet prints are water soluble and may, therefore, not be suitable for projects where you will be using glues and paints. So, if you prefer to use your own home printer, I recommend that you buy one of the many books that have been written about how to create the best prints from your at-home printer. I generally only print at home when I am using something other than photo paper to print on.

Printing in Irregular Sizes
To make a number of the projects in this book, your images need to be specific sizes that do not correspond with the standard photo sizes. Use the Crop tool to create the right size image to fit your project. To have this image printed at a photo lab, you need to create a new Photoshop document that is one of the standard photo-printing sizes. Always make sure your new documents have a 300 ppi resolution, as this is a good-quality printing resolution. If you make it a habit of ensuring that the resolution of all working images is set to 300 ppi, you will always have an image that will print at good quality. Photograph labs generally provide photographs in the following sizes:

4 x 6 inches (A6)	11 x 14 inches (B4)
5 x 7 inches (B6)	12 x 18 inches (A3)
8 x 10 inches (B5)	16 x 20 inches (B3)
8 x 12 inches (A4)	20 x 30 inches (B2)

Once you have created a standard-print-size Photoshop document, drag and drop your specific-project-size photograph (or photographs) onto it. Make sure your project photograph is also sized at 300 ppi so it matches the resolution of your background document. If the resolutions of the background and the image layer do not match, your image will not print out at the right size.

The project photograph will appear as a layer on the background. There will probably be extra space on the document, which you can use by resizing other photographs to fit into the space and inserting them. This way, you make the most of the space available for printing. Each image that is dropped onto your background will appear as a new layer. You can move these layers around so that they fit snugly next to each other. To delete a layer, merely click on it in your Layers Palette and drag it to the trashcan icon. Once you have the document ready for printing, save it as a JPEG, which will automatically flatten the layers in the image into a single layer. These days, you don't even have to leave home to order your photographs from a photo lab. You merely upload them online and wait for them to come back in the mail!

Printing at Home

You may prefer to print your images yourself on your home printer setup rather than sending them off to a lab. If so, here are some things to consider:

Paper Type: Make sure that you choose the right paper type to get the best quality print with your particular printer. Generally, the best paper for your printer is one that is the same brand as your printer. However, there are many specialty photo papers and the only way to find out which work well on your printer is to try them out. Some paper manufacturers provide sample kits of their papers for this purpose. I particularly like printing images on vintage papers.

Orientation: Before printing, you will need to tell the printer which way to print the image: portrait or landscape. If you forget this step, parts of your image may be cut off, or the printer may size it down to fit onto the page in the default orientation. When you select File > Print, you should be able to check the relevant box for the preferred orientation for your image. As a double check, you can make sure that your image will print as you intended by going to File > Print Preview. Also, make sure you are printing on the right side of the paper. As each paper is different, read the manufacturer's instructions to ascertain which is the printing side of the paper, and make sure that you insert the paper into your printer so that it prints on the correct side.

Size: Ensure that your image will fit on the paper you are using. Generally, your image will print in the center of the page. If I am printing small photographs, I fit as many as I can on to one sheet of standard letter-size paper using layers in Photoshop before printing to avoid wasting photo paper.

Quality: Select the print quality that suits your needs. Most printers give you paper type and print quality options. Every printer is different, so check your manufacturer's instructions. You can change these settings by going to the Properties or Setup menu and choosing from different quality options such as Draft, Normal, or Best for Print, and select your paper-type setting, such as matte paper, transparency, bright white, or photo paper.

SHARING YOUR PHOTOGRAPHS

There are two basic ways to share your photographs: online or by printing them. You may even want to do both. Knowing the final intended form of display will help you determine what image size and quality settings to save your file at in Photoshop. (Refer back to pages 20 – 22 for more information.)

Online: You can share images through emails, blogs, and online galleries and photography communities. Generally, you only need a resolution of 72 ppi to do this. Anything larger can result in long download times for your intended audience.

With Prints: You can either use your own printer to print your images or you can use a photo lab, be it a local lab or one to which you can upload your files online to order prints. To get the best out of your printer, I offer the same advice that I do for getting the best out of your camera: Read the instruction book and know what your equipment's capabilities are. Most times, I choose to have my photographs printed by an online photo lab. I love being able to upload the images via the lab's website and then either pick them up locally or have them arrive back a couple of days later in the mail.

(note) The results from photo labs can vary greatly. Once you have found one that works well for you and generally prints color as you like it, stay with them! Even working with only one lab, you will see a difference in their color prints if you print the same photo in different batch orders. If color is extremely important to you and cost is not an issue, use a professional lab.

ART TOOLS

There are a number of tools that you will find extremely useful for creating the projects in this book. There is always more than one way to do things, but there is also an easy way and a harder way. I aim to show you the easiest ways to get the most professional results.

Rotary Paper Cutter

This is my most important tool and is used in almost every project I create. It allows me to cut my photographs to the right size with a perfect straight edge. The straight edges will make your projects look more professional than they would if their edges were cut with scissors. My particular model allows me to cut very small strips off to get exact sizes.

Paper cutters come in many models and makes. Find one that is meant for professional photographers rather than for office use. I would recommend that you buy the best quality one you can afford, as you will use this for years to come. If your budget does not allow for this, look at using an Exacto knife or a hand-held rotary cutter. These hand-held cutters are usually found in the fabric section of craft stores, as they are used mostly for cutting fabric. However, I find them very useful for photographs, as well. If you are using an Exacto knife or a hand-held rotary cutter, you will also need a rotary cutting board so that the blade doesn't get blunt and you don't ruin your table surface.

Scoring Pad and Bone Folder

These are recent additions to my toolbox and I sometimes wonder how I managed without them for so long. The scoring pad allows you to score (make a crease mark) exactly where you would like to fold your photograph or cardstock so that you get a crisp fold. Once you have scored and folded the paper, burnish with the bone folder to make a perfect crease.

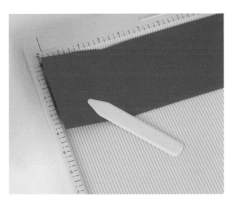

Xyron Machine

This machine allows me to turn photographs into stickers. This is really useful for projects where you don't want glue getting over everything, and it simplifies a number of projects in the book. You can get permanent adhesive or a removable adhesive for the Xyron machine. Once you've used it, you will have a hard time doing without it.

Hole Punch

I like using the Crop-A-Dile Big Bite punch. A Japanese screw punch also works well. Both of these allow you to punch holes almost anywhere on your photograph (not just near the edge), and they will also go through thick cardstock or book covers.

Double-Sided Tape

This is another really useful art supply if you don't want to get glue all over your projects. I like the Terrifically Tacky Tape, but there are many good double-sided tapes available at your local craft store.

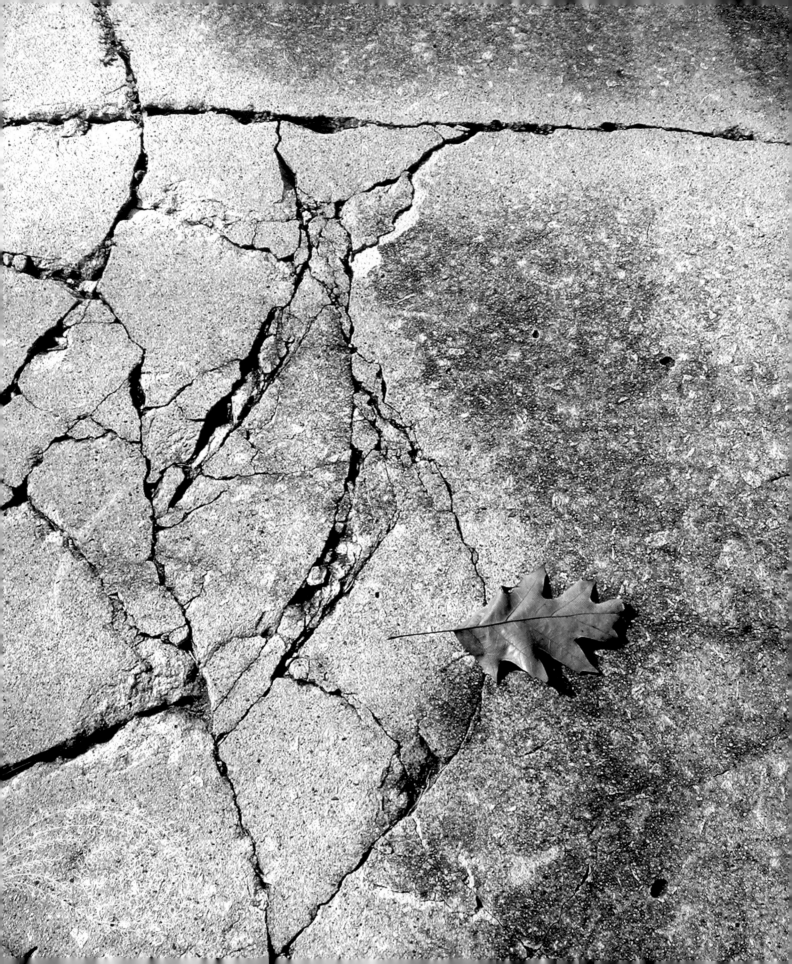

Vision *is the art of seeing what is invisible to others.*

—Jonathan Swift

As artists, how do we open our eyes to see in fresh and interesting ways? How do we allow ourselves to develop a beginner's mind so we can see with the eyes of a child again? How do we inspire our vision? How do we see the extraordinary in the everyday?

One of my favorite ways of allowing the way I see to be renewed is to look for something unexpected in the usual. I particularly like to do this when I am in a place I have seen many times before, one I have seen so often that my expectation of what I will see there hinders my ability to really see it. When you visit a new place, especially a foreign country where the colors and customs are different, almost everything you see seems interesting and worthy of a photograph. On the other hand, years of looking at the same view out of your window can blind you to the amazing world right at your fingertips. You stop seeing the familiar in any sort of unique way. We need to learn to see the world as if we are looking at it for the very first time, as if we are looking in wonder with the eyes of a child. So how do you start seeing a new world that has been there all along?

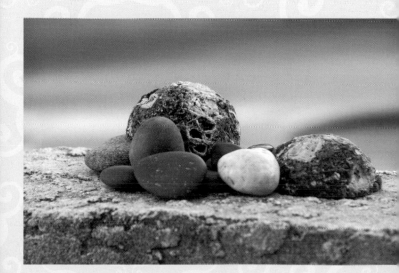

THE LANGUAGE OF VISION

Instead of looking for "things," start looking for lines, shapes, textures, contrast, patterns, color, and light. These are the building blocks for the language of vision. Instead of seeing an object as, say, just a tree, see what shapes you can find in it. What about patterns or textures or shadows? Let the object become its parts so that it is not only a tree, but it is also a vertical line, or the color green, or a shadow on the earth.

Texture: Texture relates to whether your subject appears smooth or rough, wrinkled or silky. An image that suggests to the viewer how the surface feels without them ever touching it contains this element.

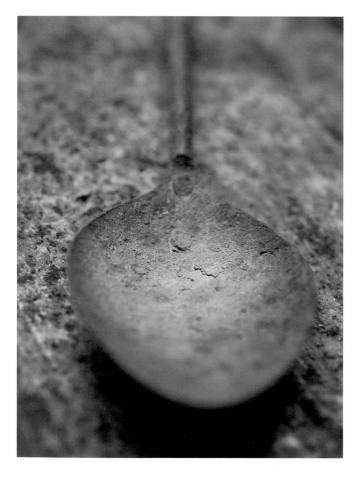

Pattern: Pattern is like a visual rhythm, a sense of order. It can give an image a feeling of harmony.

Line: Strong, defined lines in an image might be made by an element like train tracks or the edge of a building. Bold vertical lines, horizontal lines, and curved lines all create different moods. Diagonal lines are especially powerful, as they give direction and motion to an image and lead the eye where you want it to go.

Shape: Shape can create a sense of space. An arched doorway framing an image is a form of shape. Shapes can also have symbolic meaning, such as a circle or a heart.

The eye, when it opens, is like the dawn breaking in the night. When it opens, a new world is there. —John O'Donohue

Form: When you show the curves and bulges of the object you are photographing, you illustrate this three-dimensional quality. Perspective and lighting can affect the form of a subject.

Depth: Photographs record a three-dimensional world in a two-dimensional way, which means that we, as photographers, need to find ways to create a sense of depth in our images. This can be achieved by using some of the elements discussed here, such as texture and line, which helps lead the viewer into the image and create a sense of distance.

Balance: To create balance, look at both the negative and positive space when composing your photograph. Examine the arrangement of the elements within the scene. Look at the shapes these elements create. Do they complement and balance each other? The more you do this, the more you will intuitively know when the elements of color, shape, and line feel balanced in your image.

Backgrounds: Sometimes, we are so intent on the subject we are photographing that we forget to look at what is behind it and what is occupying the corners of the frame. Simple, uncluttered backgrounds work best. This may mean moving your camera position to avoid capturing an

When you start using senses you've neglected, your reward is to *see the world* with completely fresh eyes.
—Barbara Sher

unwanted element in the background. It may mean blurring your background by changing your aperture to create a shallow depth of field (see page 17). Take steps to refine what surrounds your subject so you don't overwhelm it with unwanted visual distractions.

Color: Color is an especially important element of the language of vision, so much so that I will devote an entire chapter to it. Please reference pages 66 – 85 to read about color in greater detail.

(hint) By focusing on visual elements in place of the object itself, we can learn to take an abstract view and see it as more than a mere object. It is not only an apple, it is a curved line; it has a shiny skin; it has shape and depth; it is the color red. All of a sudden, we see the apple as more than just its name and our conditioned thought of what that means.

EXPLORATION 1

Eye-Sharpening Exercises

To jump-start the process of cultivating inspired vision, begin by looking for the alphabet in unexpected places. Look for line, shape, texture, contrast, and pattern. Seeing the parts and not the whole wakes up our vision and our senses and breathes new life into the way we see the world. Places that you thought were too boring to photograph now become spaces full of interesting contours and colors. You can also expand this exercise by looking for numbers from 0 to 100 in your surroundings. These exercises will give you a new awareness of things around you that previously seemed invisible.

TRANSPARENCY TRANSPARENCY

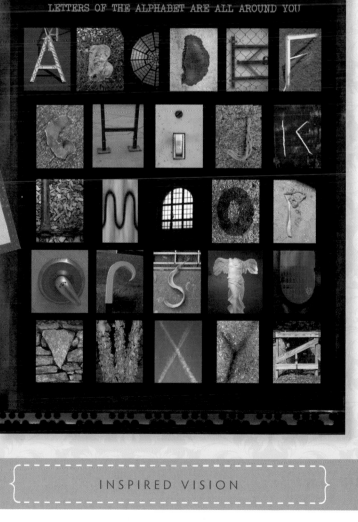

LETTERS OF THE ALPHABET ARE ALL AROUND YOU

{ INSPIRED VISION }

EXPLORATION 2
Alphabet Box

Find or buy a recipe box or card index box for 4 x 6-inch (10.2 x 15.2-cm) index cards. Insert alphabetical dividers, or make your own by placing alphabet stickers on cardstock dividers. This will allow you to file your alphabet photographs as you slowly build up your library of images. You could have a box for letters found in nature and another one for architectural letters. The shapes of buildings can suggest a range of letters. Decorate your box with some of the photos so it becomes not just a storage container, but a place to showcase your images. The more you look for letters in your surroundings, the more your ability to see things you had previously not noticed will develop and expand. You can use these found letters to spell out names or favorite words either by printing out the individual letter photographs as I did in the project on page 33, or by using Photoshop to join the individual photographs together to form one image (as shown below).

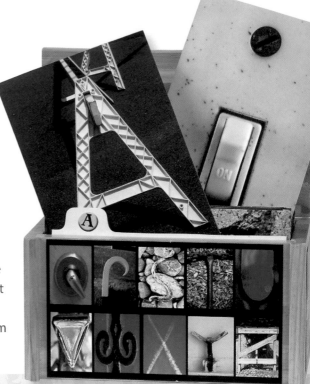

EXPLORATION 3
Words from Images

Choose any word you like for this project. Create a piece of artwork for your house or create a framed image of a family name as a gift for a friend. Decide on how large you would like your finished image to be and create a new Photoshop document that is large enough to contain all the letters you plan to use. It is easiest if your letters are all the same starting size, such as 4 x 6 inches (10.2 x 15.2 cm) at 300 ppi. You can then create a new document that is 6 inches (15.2 cm) tall, with the horizontal dimension being determined by

multiplying the number of letters in your word by 4 inches (10.2 cm). Drag and drop each letter into your new document and line them up beside each other. I always save my original in its adjustable PSD (Photoshop document) form in case I want to change something later. You will also need to save a copy of the image as a JPEG document so you can print it at a photo lab. I sometimes convert the image to black and white to unify any disparate colors and allow the shapes of the letters to be more prominent.

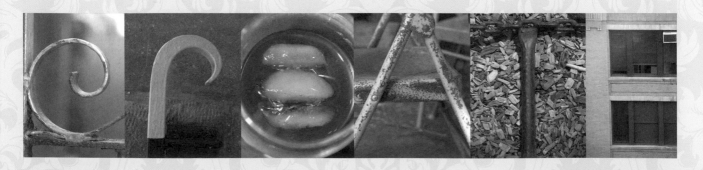

EXPLORATION 4
Creating a Word Banner

To create a banner, start by printing out 4 x 6-inch (10.2 x 15.2-cm) photographs of your individual alphabet letters. I like to print in matte or luster so the photographs don't look shiny. For the individual flags of the banner pictured at right, I used a canvas fabric that I tore into rectangles that were slightly larger than my prints. Take a ribbon or string that is long enough to span the entire banner, plus room on the ends to hang it. Then, fold a hem into the top of each flag, tucking the ribbon inside, and sew it down. When I do this, I like to continue the thread between each flag so that they stay connected. This also saves time since I don't have to cut the thread at the end of each hem. Glue the photographs spelling out your word to the flags using craft glue, or you can sew the photos in place.

If you do the work that you do from a *loving heart*, then you will always be able to make something beautiful. —Zen Proverb

{ INSPIRED VISION }

CREATING SHAPES AND FORMS

As well as making letters, you can also use stones, sticks, and other objects to make shapes such as hearts, spirals, circles, and flowers. Artist Andy Goldsworthy is a sculptor who creates work out of natural elements such as flowers, leaves, stones, and even ice. He creates art that deteriorates with time and preserves his creations by photographing them right after he creates them.

For years, Buddhist monks have created beautiful, intricate mandalas out of millions of grains of colored sand. These mandalas can take weeks to complete, and once they are completed, the monks ceremoniously destroy them. This process is a metaphor for the impermanence of life and the ideal of non-attachment to the material world. Half of the sand is distributed to those present at the closing ceremony, and the remainder is released into a nearby body of moving water to be carried to the sea to bless and heal the planet.

Do you remember writing in the sand at the beach when you were a child even though you knew that, by the next morning, your words would be washed away by the tide? By photographing your natural creations, such as words in the sand, you can share them for more than just a day. You can even create a shape or word out of sunflower seeds to be enjoyed by our feathered friends after you have had fun recording it with your camera.

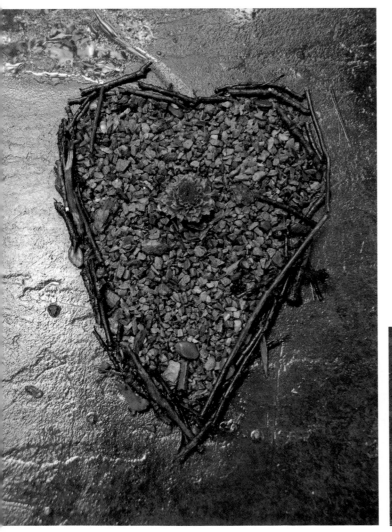

{ WITH YOUR CAMERA }

EXPLORATION 5
Create a Natural Sculpture

Create your own natural sculptures on a small scale. Look around and see what you have at home—white rocks, a jar of buttons, a packet of dried beans in your grocery cupboard. You can also use fresh flowers from your garden or leaves picked from a tree. Create a shape that speaks to you, then photograph your creation and share it with others.

If this sounds too complicated, you can use chalk to write messages on the sidewalk or your driveway and photograph these. Creativity is about doing things in your own unique way. Consider creating your sculptures in places where they might be unexpectedly found by someone and bring some beauty to their day.

EXPLORATION 6
Visual Idea Journal

Another way to gather inspiration for your photography is to look through old magazines, catalogs, the Internet, or even books on the history of photography. Where possible, cut out images that you wish you had photographed.

Paste these in a large scrapbook or collect them in a file on your computer so that, when your imagination is a little slow, you can use these images as a jump-start. If you prefer to do this on your computer, check out www.weheartit.com. You can create a file of your favorite online images in your own "heart-it" file to inspire you. However you compile these images, and wherever you pull them from, allow them to inspire you to photograph in ways you may not have considered.

This is also a great way to find out what sort of images you are drawn to. For instance, you might find that all the images you collect are of flowers. It is good to know what speaks to you. You can then visit a local botanical garden, or spend time in your own garden photographing flowers in many different ways, seeing if you can get some of the effects in the magazine images you have collected. You might even be inspired to plant flowers of your own to photograph.

My visual idea journal is a continual resource of ideas. Use the images in yours as a starting place. Let them prompt you to create. I find that images inspire me more than a list of subjects I'd like to photograph does; they open me up to interesting angles and compositions I might never have thought of otherwise.

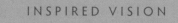

INSPIRED VISION

PRACTICE MORE, PLAY MORE

At *National Geographic Magazine*, photographers average approximately 12,000 individual photographs for each story. Only about ten of those make it into print. Photographer David Hurn says that he finds one exhibition-quality photograph for every 3,600 photographs he takes. However, unless your goal is to have your photographs displayed in museums, don't let this put you off. Focus on the process and how it helps you express yourself rather than focusing on perfection. Who decides what is perfect anyway? Like all art, photography is a subjective process. An image that speaks to me may not speak to you. Photograph for yourself, not for others. Let photography be your form of relaxation and play.

What I learned from the National Geographic photographers is that we need to develop the patience it takes to think of the different ways we can express our subjects, and this means looking deeply at those subjects, from all angles, in all lights, and in all ways—close up, from a distance, as abstract, as lines and shapes, as color, as light. When you photograph, ask yourself if there is another way you could express the subject. Sometimes, the slightest change in position or a change in camera controls can turn a photograph into something breathtaking. But don't expect a perfect photograph every time. Remember, the more photographs you take, the more likely you are to have some spectacular ones.

Photographer Edward Weston spent years photographing green peppers until he perfected his art. This took passion, dedication, patience, and the recognition that even the simplest subjects have much to offer. The best way to improve your photography is to practice and experiment over and over again. Unexpected creative insights only come when you are willing to spend time being in the flow of the process without worrying about the outcome.

Experimenting and playing are one and the same to me. I play with no expectations about my results, and I am often rewarded with new creative ideas or a step toward a new way of doing things. The more you are willing to play and experiment, the quicker your photography will improve, and the more fun you will have doing it. Creativity is a process, not a product.

As you spend time looking at the world through your newly awakened sight, start noticing any shifts in your body. When I see an object or a scene that speaks to me on an unconscious level, I feel an almost imperceptible shift in my breath. It is almost as if the scene "takes my breath away" and my breath stops for a moment. When this happens, I know I need to make a photograph of the object or scene. This is a feeling of awe, a recognition of beauty, a sense of meaningful connection.

Art does not come from thinking but from responding.
—Corita Kent

From hundreds of photographs I made of this dandelion, this one, showing a solitary dandelion seed moving into the world, really spoke to me.

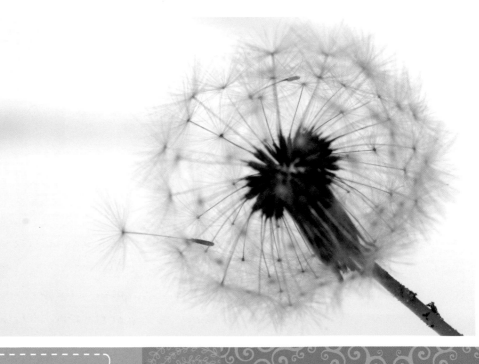

EXPLORATION 7
One-Hundred Images

Choose one thing. Anything. It could be a single flower, your daughter's hands, a bowl of eggs, a dandelion—really, anything! Take at least one hundred photographs of only this one thing. Really see and get to know your subject. Take the photographs at different times of day, in different lights, in different places, in different positions, at different angles. Take close-up photographs, look down on your subject, look under your subject. See how many ways you can look at the same thing. Pretend you and the world have never seen this subject before and will never see it again. Your photographs will be the only way the rest of the world can get to know what you are photographing. Express the essence of the object through your images.

I consider this exercise to be a photographer's version of a "first draft." There are some photographs you will want to delete, but there might be some good ones and, every now and then, you may even get some great ones. The important thing is to photograph something, just as the writer needs to write something if he/she intends to improve their craft. You could consider these photographs a form of daily visual journaling or "morning pages" (a process Julia Cameron describes in her book *The Artist's Way* in which you write three stream-of-consciousness pages each morning upon waking). Do this exercise again and again with new subjects. Even if this is the only exercise you do from this book, your photography will improve.

There are an almost unlimited number of ways to photograph a single thing. With each click of the shutter button, you are getting to know your subject more fully and opening your eyes to new ways of seeing.

We must be willing to *experiment and take risks* in order to make great images; above all, we must be willing to *accept our own intuition*. This requires us to have confidence in our own abilities, something we gain through practice and experimentation. *Every time we press the shutter* we need to make a *leap of faith* as well as a leap of the *imagination*. —Minor White

{ INSPIRED VISION }

EXPLORATION 8
Map Book

You are bound to take at least a hundred photographs when you visit a new place. This project recycles the city map you picked up while visiting and turns it into a map book of your photographs. Maps are usually pre-folded, so you can use existing lines. If you wish to change the dimensions of the folded sections in your map, lay your map out and fold it in half, then fold each side in half towards the middle to create 16 total sections, as shown in the diagram on this page. You can use the whole map or just a portion. Your pages can be rectangular or square, depending on how you decide to fold your map.

Once you have folded your map, unfold it and cut along the folds as shown by the dotted lines on the diagram at right. Then, fold your book starting at one end. The "pages" will fold behind each other into a book format. Paint a black background on each page for your photographs, or you can add photographs without a background.

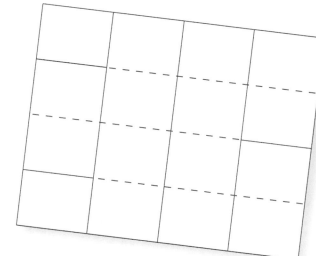

Right: After cutting along the dotted lines as indicated, start folding the pages. Practice folding the map into book form before attaching the photographs.

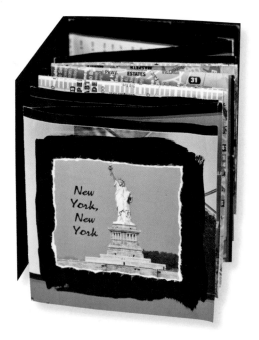

Left: The map folds into an accordion-style book.

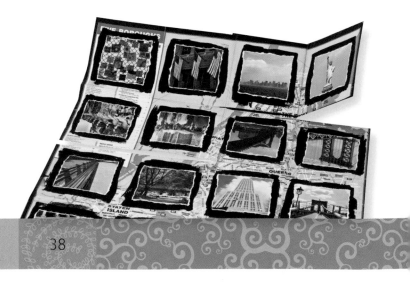

POINTS OF PERSPECTIVE: SEEING IN MANY WAYS

There are hundreds of different ways to see a subject. One of the first things I do when I come across something I want to photograph is walk around it slowly (if that is an option), noticing if different backgrounds enhance the subject or clutter it, noticing where the light is coming from and whether there are shadows or backlighting or silhouettes, noticing how the colors of the subject look from different angles. This allows me to decide on the best vantage point from which to make the photograph.

Sometimes you'll want to shoot from above to maintain a certain perspective or achieve a bird's-eye view of the subject. Other times you'll want to be looking up at the subject to give it a sense of height or grandness within the frame. You will discover the best creative vantage point only from exploring all the possibilities.

Above: The image isn't always directly in front of you. Remember to look up! You might see things you have never noticed before. Try lying on your back with your camera and see how different things look. Notice everything around you and decide what important elements you want to include in your photo.

I photographed this labyrinth in my backyard from the top of a six-foot (1.8 meter) ladder. I waited for an overcast day so I didn't have shadows on the labyrinth, and I watered the grass before taking the photograph to enhance its rich, green color.

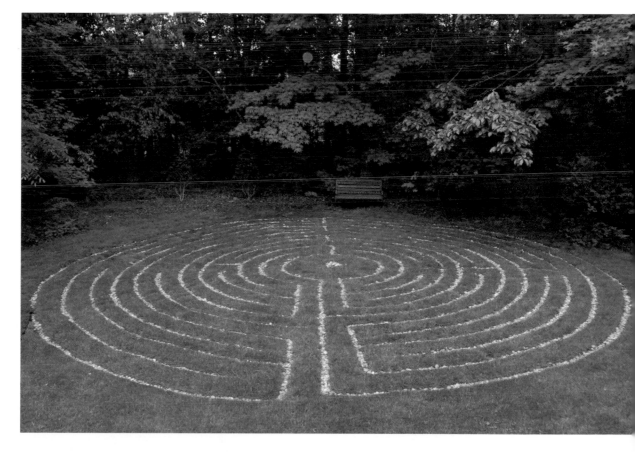

INSPIRED VISION

EXPLORATION 9
Seeing with Ant Eyes

How would you see if you were an ant? What about a dog, or a small child, or a bird? Experiment with trying to see from these different perspectives. Lie flat on the grass, climb a tree, stand on a chair or ladder, or sit on the ground and take a series of photographs only from that level. (Please be careful while tree climbing or standing on chairs and ladders!) Take at least fifty photographs from each of your selected vantage points. You will discover that the world looks different when you change the level of your vision.

EXPLORATION 10
Visual Vocabulary

I find it hard to express myself adequately with words. This is one of the reasons I turned to photography. I am able to express myself more fully through my images.

There are messages for us in inanimate objects. A pathway can remind us of the journey of life; a boat can remind us of adventure and freedom. The meanings are different for each of us, depending on our inner history and memory. Everything we see has an implied, non-verbal meaning, and photography is a way to share in this form of communication. There is far more left to the imagination when expressing yourself in images rather than words. Sometimes our images even tell us things we were not aware of at the time we took the photograph.

To extend your personal visual vocabulary, start by making a list of words that you particularly like. Once you have created your list of words, look for subjects and scenes to photograph that express the words you have chosen. Let your images convey the meaning in silence. Let images be your new vocabulary.

If you need a good starting point, find an old dictionary; these are easy to find at thrift stores. Cut out any words that would be interesting and challenging to photograph. For example, think about photographing the word "nourish." What does "nourish" mean to you? What about the word "abundance?" Include some words that will encourage you to be creative in your search for an image that best describes the word and stretches your creativity. Pretend that you have to photograph these things so that someone who can't read or hear can understand what they are. Get a group of friends together and challenge them to take photographs of these words with you.

il lu mi nate (i lü′mə nāt), *v.,* -nat ed, -nat ing.
1. light up; make bright: *The room was illuminated by four large lamps.* **2.** make clear; explain: *Our interesting teacher could illuminate almost any subject we studied.* **3.** decorate with lights: *The streets were illuminated for the celebration.* **4.** decorate with gold, colors, pictures, and designs. *Some old books and manuscripts were illuminated.* **5.** enlighten; inform; instruct. **6.** make illustrious. [< L *illuminare* < *in-* in + *lumen* light]

The photographs we make can be food for the soul, nourishing sustenance for the arduous and confusing journey we're on. We are all hungry for meaning, all in a quest to realize our worth, actualize our potential, manifest whatever is unique to us. —Jan Phillips

PHOTOGRAPHY AS SELF-EXPRESSION

When we create from the unity of body, mind, and spirit, we are one with our muse, and our work is always original, always powerful.

—Jeanne Carbonetti

BECOME A VISION MAKER

The role of the artist has always been firstly that of the observer and secondly that of the reporter of those observations through the lens of the artist's own mind. Seeing is not a task that can be delegated. We each have a highly individualized perception of the world around us, seeing it through the lens of past experiences, present beliefs, and learned responses. We are more likely to see something we are already fascinated by or attracted to. If you have ever spent time with an avid birder, you will know this is true. They "see" not only with their eyes, but also with their ears. They are attuned to the slightest movement of a leaf. Animal trackers, like birders, use their accumulated knowledge and experience to decode signs like smell, movement, and footprints to lead them to an animal. These tools of keen observation are also essential to photographers.

We don't just use our cameras to make an image; we use every part of ourselves to envision and create it. Our "vision" is both literal and metaphorical, encompassing not only our eyes but also our intellect, our emotions, and our other senses as well as our passions, our likes and dislikes, from our favorite songs and colors to the books we read. We put all these things into each moment of observation.

Every day, the light is different. It will never look just like this again. You will never have this day again, and no two photographs you take will be exactly the same. Ask yourself, "Why do I photograph?" Once you know where your interest lies, you will be in a better position to hone the way you observe and see more of what speaks to you. I photograph because I want to share the exquisite beauty of the world with others. This can take the shape of the way light falls on water, the intense green of the morning grass covered in dew, or the steam rising from my cup of coffee.

I am always looking for things that speak to me of the beauty that surrounds me on a daily basis, and so it seems that I am constantly surrounded by moments of beauty. We are drawn to photograph things that resonate with our innermost selves, and once we start looking for something, we seem to see it everywhere. You can prove this by giving yourself an assignment to photograph a certain subject. Notice whether or not you see more of that subject than you ever did before you focused your awareness on it. We miss so much in our rush to live life.

EXPLORATION 1
An Artist's Date

Your camera is your friend. Even if you keep your camera with you regularly, you still need to plan a date with it at least once a month. Take your camera to the zoo, to the local botanical garden, or to the river. Think of places your camera has never been and take it there. Then, of course, once you have it there, use it to record the experience.

Another option is to ask a group of friends to bring their cameras and come along with you. Pack a picnic lunch and head off on a road trip, stopping whenever you see anything you would like to photograph. Or, plan a trip to a specific location and draw up a list of things you want to photograph, then compare photographs over a cup of tea or coffee. This is a wonderful way to build up your library of images and improve your artistic vision.

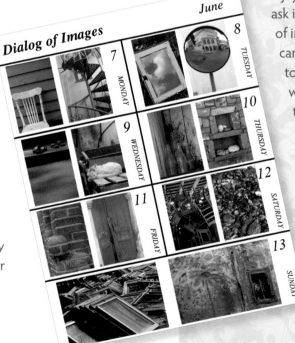

EXPLORATION 2
A Dialog of Images

There is something special about sharing images that speak to us. My twenty-year-old daughter recently went on a trip to Crete and, while she was away, I suggested that we have a "dialog of images," sharing images via email of things we saw that spoke to us. This way, I got to share small, everyday things that only my daughter would appreciate, and she made photographs of things I suspect she might have passed by if she had not been thinking of me. And of course, one could read unconscious feelings into the images if one chose. For example, the first few photographs I shared with my daughter had a lonely feel to them, such as a white chair against a blue wall (which could also be an unconscious wish to be in Greece, where white and blue are dominant colors). When I took the photo, I certainly wasn't thinking of that. The image was just speaking to me, and I listened and recorded it.

Think of a friend who lives far away and enjoys photography. Contact them and ask if they would like to start up a "dialog of images" between the two of you. You can do this by email or you could choose to start a blog recording your images, where on alternate days you respond to the images posted by your partner. Of course, you could also do it by mail, both of you mailing a photograph every Monday to each other. Keep a copy of your photograph for yourself as well, and once you've collected a year's worth of images, you can create a book with the photographs. A series of these over the years can tell as much about you as any written journal.

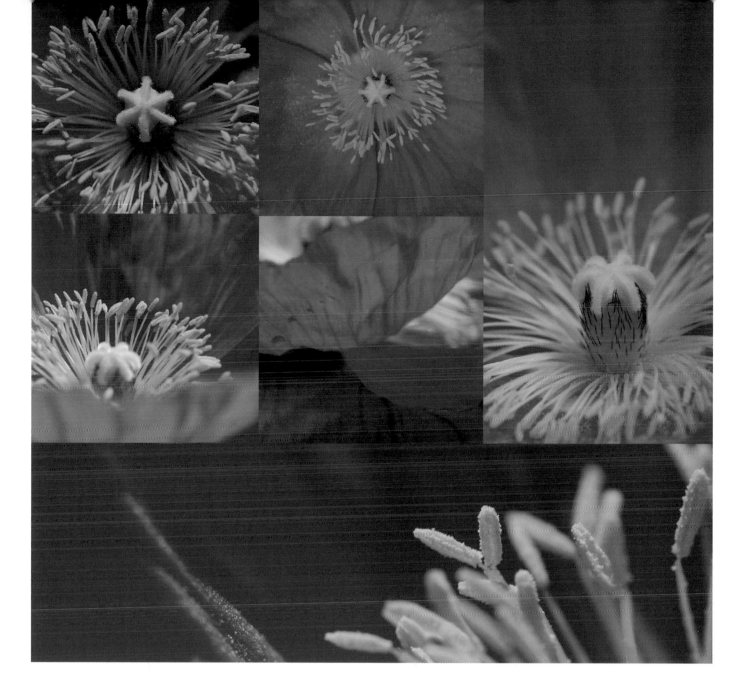

To make images is a way of ordering one's world, of exploring and understanding one's relationship to existence[.] … The images we make are often ahead of our understanding, but to say "yes" to a subject is also to have recognized, however dimly, a part of oneself; to live with that image, to accept its significance is perhaps to grow in understanding. —John Blakemore

PHOTOGRAPHY AS SELF-EXPRESSION

EXPLORATION 3
Compassionate Photography

I remember the moment I realized that photography had the ability to change the way people saw things, that it could inspire people to help others. It happened while reading about the photographer Lewis Hine, who used his photographs to expose child labor in the mills in the Carolinas in the early 1900s. His photographs helped change the legislation to protect children against exploitation. Images do speak to people, and I believe they have the ability to change lives.

This prompted me to take a trip to South Africa to spend time with Woza Moya, a community care and support program in Ixopo, KwaZulu-Natal that was involved in caring for orphans of the AIDS crisis as well as providing home-based care to people affected by AIDS. To tell the truth, I was terrified. I had no idea what I would find when I went there. I had never done anything like that before, and it changed my life. Spending time with children affected by AIDS was a humbling experience.

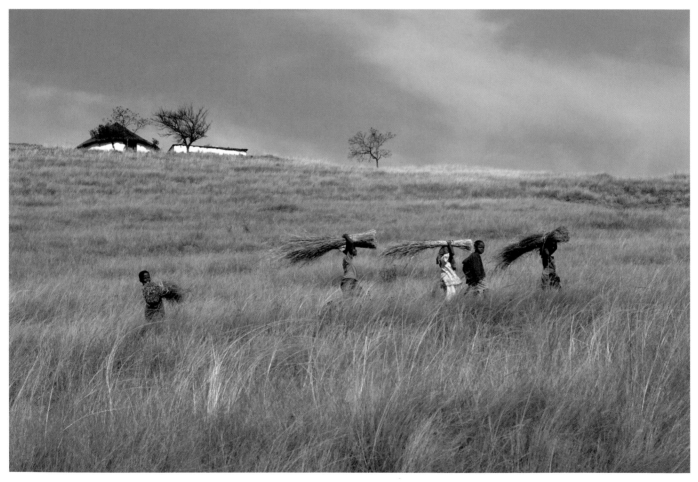

When you encounter an image that stops you, that provokes you, that outrages you, that entertains you, it goes beyond the intellectual into an **emotional and spiritual space.** *—Chris Rainier*

These beautiful children had an inner joy and love that allowed them to live in the present moment and not let the direness of their circumstances affect the way they lived. I also spent a day with the "gogos," the generation of grandmothers who have become caregivers to many of the children left orphaned. Their strength and determination made me realize just how much I had to be grateful for.

One of the aspects I was concerned about when I took this trip was that I wanted to express the dignity and beauty of the people and connect to their courage and human spirit. I wanted to be respectful. I didn't want to focus on the poverty because I didn't want to take advantage of their circumstances. These are things to bear in mind if you are drawn to use your camera to increase awareness of social issues that need to be addressed. I believe that a few sensitive photographs can arouse more interest and compassion than words alone. I was able to use my photographs to share the stories of the children upon my return to the United States, and this resulted in the support of many orphans in the school program. Learn as much as you can about the cause of an organization that appeals to you and think about how your images can tell a story.

(hint)

You don't have to travel halfway across the world to make a difference. There are plenty of local organizations that could use your help. If you see fundraising events advertised in your local paper, contact the organization and ask if they would like a volunteer photographer.

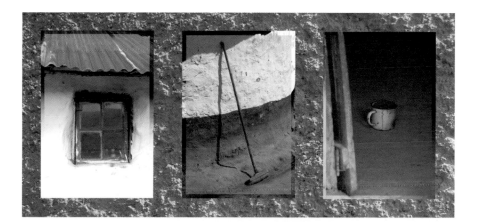

Above: While I was walking along the dirt roads with my camera, I picked up pieces of tin, bone, feather, newspaper, and other "found objects" that had the feel of the place I was visiting. I brought these back home with me and used them to create a frame around one of my favorite photographs of a little girl in Ixopo. I also covered the photo with a layer of beeswax so it would fit with the worn look of the found objects.

Left: Remember that sometimes you can say a lot with a little.

EXPLORATION 4
Random Acts of Photography

If teaming up with an organization doesn't appeal to you, your images can still make a difference. You could choose some of your favorite images of a subject or issue that matters to you, add uplifting quotes or positive thoughts to the backs, laminate them, and leave them at random places around your community. Someone who needs that message might just find your photograph. As the bumper sticker says: "Practice random kindness and senseless acts of beauty."

A great photograph is a full expression of what one feels about what is being photographed in the deepest sense, and is, thereby, a true expression of what one feels about life in its entirety.
—Ansel Adams

EXPLORATION 5
Random-Acts-of-Photography Tin

I've also made tins containing my random acts of photography and given these as gifts to friends. This is a particularly thoughtful gift for a friend going through a hard time. You can choose your photographs and quotations specifically with that person in mind. You can use tins that are made for sports trading cards, or gift-card tins. I resize my images so that they will fit snugly into whatever tin I am using.

You can cover your tin by cutting out letters from magazines and pasting them on a piece of cardstock cut to the size of the tin lid. Once I create the cardstock cover, I scan it so it can be used many times. I also like to include a note on the back of the tin, such as: "This is a collection of 'random' photographs taken with the intention of merely recording whatever caught my eye. With the photographs are some of my favorite quotations, which inspire me to continue in my search to make life a creative and artful experience." Your note could be appropriate for the person you are giving it to, or a more general note if you plan to make these tins for all your friends for the holidays.

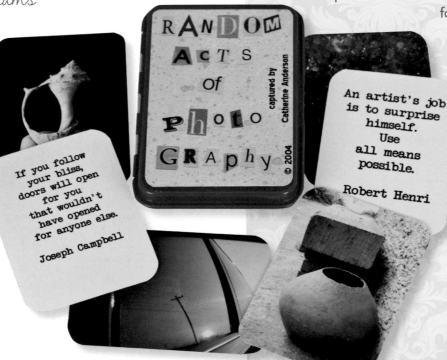

If you follow your bliss, doors will open for you that wouldn't have opened for anyone else.

Joseph Campbell

rANDOM AcTs of PhoTo GRAphy

captured by Catherine Anderson

© 2004

An artist's job is to surprise himself. Use all means possible.

Robert Henri

EXPLORATION 6
Photo Cards

In these days of instant email, sending a card through the mail is a way to let people know how special they are to you. The fact that you have taken time to choose an image you think a friend will enjoy will be appreciated. Have some of your favorite images printed out and incorporate them into your cards.

There are many different ways to create photo cards. You can print them on your personal printer, but I have found that my favorite quick and easy way to create cards is to use Strathmore Photo Mount Cards. These come with double sided tape squares for attaching the photograph to the embossed card. What I love about these cards is that I can have a selection of photographs printed, and when I need to create a card for a particular person or occasion, I can go through my photographs, find one that is appropriate, and make the card immediately.

If you want to sell your cards, or give a set of cards as a gift, you can insert them into clear bags. (I purchase my card bags from www.clearbags.com.) To start feeling like an artist, print labels for the backs of your cards that contain your name and website or email so that anyone can contact you for more cards, or even for a print of your image. When you give cards as a gift, you never know where your cards might end up. I've been excited to learn that one of my cards was sent to a Pulitzer Prize winner. I use Avery 1 x 2 5/8-inch (2.5 x 6.7-cm) clear address labels for the backs of my cards.

If you want to spend more time making your cards, the options are endless. You can collage photographs onto various backgrounds; you can cut up your photos and make montages; you can tear the edges of your photographs to add texture; you can use hole punches to cut your photographs into different shapes. Boxes of plain cards and envelopes can be purchased at your local craft store or business-supply store. Try out

different sized cards when you feel like doing something creative.

Learning to tear photos and papers was one of the most freeing moments in my life. I had always tried to cut straight, but I discovered a completely new approach when I realized that torn edges were creative. They can make things look more interesting. They add depth and create a border. Use an ink pad to color the edges if you wish. Practice tearing some old photos. You have to tear in a certain direction to get the white border. Play with old photos that you were going to throw out anyway and see how you can use these.

Try other borders, too. Cut a piece of black cardstock a little larger than your photograph and layer it under the photo. You can also create a border by using paint on a sponge around the edges of your image. Gold paint works well for this.

Use cardstock and your scoring pad to make mini cards cut to the right size for miniature images. Consider gluing a texture, such as string, around the edge of your photograph, or sewing the photo onto the card to add more dimension. I also like to create borders using Photoshop Elements and print these out for my cards (see pages 60 – 61 and 128 – 129).

EXPLORATION 7
Photo Tags

First, I decide on the size of my tag. One of my favorite sizes is 2.33 x 5 inches (5.9 x 12.7 cm), as I can then fit three tags on a 5 x 7-inch (12.7 x17.8-cm) print. I then paste plain or colored paper over the back of the print and cut it into three tags. I cut the top of each tag and punch a hole through it, using a shipping tag as a template. Finally, I embellish my tags by threading colorful yarn through the tag hole.

Photographs make great tags to attach to gifts. You can use a standard shipping tag and paste a photograph on top of the tag. You can also make your own tags by cutting cardstock into tag-like shapes and pasting your photographs on those. I like to create my tags in Photoshop.

EXPLORATION 8
Gift Bags

As a creative photographer, there is no need to buy gift bags. You can give a little of yourself by creating your own recycled and upcycled gift bags. Any photograph that can go on a card or a tag will probably also work on a bag. Recycle paper bags by gluing your photographs over logos of stores, or sew your own fabric or canvas bags with your photograph sewn on the front. You can also upcycle plain brown paper lunch bags by gluing on a photograph, punching two holes in the top, and adding a ribbon.

EXPLORATION 9
Making Bookmarks

Bookmarks can be made in a similar way to the photo tags (detailed in the exploration at left). The standard size for a bookmark is usually 2 x 7 inches (5.1 x 17.8 cm). You can fit two of these on a 5 x 7-inch (12.7 x 17.8-cm) print. You don't have to stick to this standard size, though. You could make each bookmark half the width of your print to use up all the space.

If you want your bookmark to have a front and a back, you can print each side and glue them together. Sometimes it works better if the back is printed on thinner computer paper. You can use either a whole photograph on the bookmark, with or without text, or you can use a smaller image with text. Cut the bookmarks apart with your paper cutter, glue a sheet of paper on the back to cover the back of the photograph, and you have a bookmark using your own images. You can also choose to round the corners, or even punch a hole and add a tassel.

Creativity is the voice of the spirit. One's art should be the extension of oneself.
—Maritza Burgos

EXPLORATION 10
Gift Boxes

Recycle small gift boxes by covering them with your images. Start by pasting a layer of black cardstock on top of the box, which will create a border around your image. Alternatively, you can also create a border around your photograph in Photoshop before you print it. Attach the image with double sided tape or glue.

EXPLORATION 11
Recycled Jars

Another idea is to share flowers from the garden by placing them in old glass jars decorated with your photographs. This is a perfect gift to leave at your neighbor's front door. Clean an old glass jar, choose a photograph you like, and cut it to size. Attach it to the jar with double-sided tape or Xyron. You can also create storage jars for yourself or a friend using this method. Print your images out on self-adhesive full-page labels, cut them to size, and then adhere them to your jars.

EXPLORATION 12
Adding Text to Images

It is easy to add text to photographs using Photoshop. When taking photographs that you might like to add text to, you will need to be conscious of leaving some negative space somewhere in the image, space where there is not much detail. Negative space allows you to add text without making the image look too busy. Use the following steps as a guide to placing text in your images using Photoshop Elements.

Step 1: Open your image and size it to whatever size you intend your final piece to be. You can do this by going to Image > Resize > Image Size, or by using the Crop tool.

Step 2: Select the Text tool and click on the image at approximately where you would like your text to appear. Choose your font, font size, text alignment, and the color of the text from the menu at the top of the screen, then start typing your words.

Step 3: Type in your text. You can then move the text box around within the image to optimize placement using the Move tool (figure 1). You can also change the font, font size, alignment, and color of the text by highlighting the text and using the menu bar to change your selections.

What you leave behind is not what is engraved in stone monuments, but what is woven into the lives of others.
Pericles

Find a quote you love and seek out the perfect photograph to illustrate the words. Be sure that the photograph deepens the meaning of the quote, adding emotion to it. Using your image-processing software, add the quote, making sure that it is added in such a way that it does not distract from the image. Alternatively, the text can be included at the bottom of the image in its own space. Choose a font that fits the image, as the way the letters appear also speaks to the viewer and can indicate that the message is a formal, playful, or sensitive one, among other things.

You can print this photo-quote combination out as a poster to display in your home or give to a friend as a gift. If you enjoy this type of project, you could also consider creating a small book of inspirational quotes and photos, with the quotes on one page and the images on the opposite page.

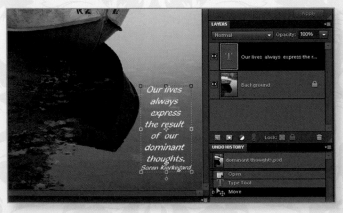

Figure 1

EXPLORATION 13
Photo-Covered Notebooks and Journals

As you know by now, I love giving gifts that show a little of my view of the world. Notebooks are a great gift, as they can be used for purposes from the practical to the creative. And we all know that artists carry notebooks with them wherever they go.

Small, spiral-bound notebooks are easy to cover. To cover the front of the notebook start by straightening the wire binding and uncoiling it from the notebook. Then, size a photo to fit the notebook (allowing a little extra around the edges), have it printed on photo paper (or use some other unique paper), and glue it onto the cover. I use my Xyron to do this. Trim the edge so that it fits the cover perfectly. If there is writing on the back, I cover this in black paper, but you can cover it with anything, including another photograph. I love putting quotes on the covers of the notebooks I make.

To create your very own mini notebooks from scratch, use a standard-size photograph to make up the full cover. Consider using a photo that includes text and/or borders to make it look even more like a purchased mini notebook. (Refer to page 52 for more about adding text to images; refer to pages 60 – 61 and 128 – 129 for information about creating image borders.)

Fold the photograph you have selected in half, then cut three or four sheets of paper to fit inside the photo book cover. Fold the papers in half, insert them into your folded photograph, and sew the whole thing down the center. (I use a sewing machine, but you can also sew this by hand.) Cut two additional pieces of paper to fit the inside front and back covers and glue these onto the undersides of your folded photograph. Alternatively, you can paste another photograph into the inside front cover.

The plain, school-composition books are also very easy to transform with your photographs. Choose two photographs that you like and print them out large enough to cover the front and back panels of the composition book. I find that a standard 8x10-inch (20.3 x 25.4-cm) print works well. Using glue (or a Xyron machine), attach the photograph to the cover of the composition book and trim down the edges.

{ PHOTOGRAPHY AS SELF-EXPRESSION }

FINDING YOUR UNIQUE VOICE

How do we find our voice as artists, our own unique way of creating that reflects each of our individual personalities? Sometimes it is hard to know where to start. Author Sabrina Ward Harrison suggests, "We must create what we most need to find." I think that this is a perfect place to start. Pick up a journal and write about what it is you most want today. Is it something universal like peace, or is it something simple like picking your own fresh vegetables from your garden? What do you want to communicate to the world? Gandhi said we should "Be the change we wish to see in the world." Let your photography reflect what you wish to emphasize about the world as you see it. This will take you on a journey to doing things in your own unique way. Indeed, many artists became well known because they did things their way, creating art that was different from the norm.

The eye encompasses the beauty of the whole world. —Leonardo da Vinci

{ WITH YOUR CAMERA }

EXPLORATION 14
Seeing Like Leonardo da Vinci

Imagine what interesting images the world would have if photography had been invented when Leonardo da Vinci was alive. Think of those amazing journals he left behind, full of his ideas. Imagine what he would do with all the technology that is available today. Leonardo was curious. He was patient and persistent. He was willing to learn new things. He used his senses.

For this exercise, I challenge you to find out more about how da Vinci saw the world. The book *How to Think Like Leonardo da Vinci,* by Michael Gelb, is a perfect resource. Spend a week or two photographing things that you think would have fascinated Leonardo. Consider how you think he would have explored these subjects with a camera. Would he have photographed landscapes or people? Would he have photographed a certain subject up close, or from a distance? Put yourself in his shoes and see the world through his eyes.

Are there any other people who lived before cameras were invented that you would be interested in centering this exercise around? What about Plato, or William Shakespeare? Read a biography about the person and try to understand their way of thinking. Trying to see the world from another person's perspective can help to broaden our own worldview.

UNIQUE PRINT SIZES

Don't limit yourself to using only traditional print sizes for your images. Thanks to Photoshop, we can adjust our photographs to nearly any size, limited only by the resolution of our cameras and the availability of a printer who can meet our sizing needs. You can create panoramic photographs, square photographs, circular photographs, or any shape you choose with the right tools. Don't let the sizes and shapes you are accustomed to determine what is best for your project. Look for something different, especially when you are creating cards and images that do not need to be framed in a traditional manner. Check out Moo Cards: us.moo.com. You can order a set of 100 different images in small mini printed photographs, which can be used as business cards, pasted on cards or tags, or used as gift tags themselves.

EXPLORATION 15

Photographs as Collage Elements

I use all my photo scraps—the bits that I cut off of photographs—for creative projects. For example, they can make interesting borders around journal pages, or you can use them with shaped hole punchers to punch out different designs to add to gift tags. You can also use these scraps in a collage, in addition to images you select specifically for this purpose.

In setting out to use your photographs to make a collage on paper (rather than a digital collage using Photoshop), become more aware of taking photographs that have clear edges and can therefore easily be cut out with scissors and combined with other images. When taking photographs that you plan to use in collages, you may want to focus on getting the subject represented clearly (i.e., making sure that petals from the flower you plan to use haven't been cut off at the edges of the frame). This is particularly important for the main subject of a collage; it can be even more important than the composition of the photograph, as the intent for such an image is not the composition, but rather a clear rendition of the main visual element. You will be extracting this visual element from the photograph for your collage, so the background and placement of the subject become irrelevant.

Before you start a collage, it is helpful to have a diverse array of subjects, backgrounds, textures, shapes, and other elements that can be cut out and combined. This will allow you to be more creative with your collage composition. If you find a particular subject that you know you would like to use in a collage, such as a statue or person, visualize what kind of background setting you might like to place your subject against and what other elements might add depth and meaning to the subject. Then, look through your photographs and see if you have anything that fits. If not, this is a perfect excuse to take your camera on an adventure, searching for the perfect background or element to complete your collage.

55

UNIQUE PAPERS

You can use paper other than traditional photo paper to print your images on your home printer. I have even used old ledger paper and old book pages. You can try brown paper bags or old receipts. Cut your paper to a size that will go through your printer. This is usually the standard letter size. If the paper you want to print on is smaller than that, you can use masking tape to attach it to a sheet of printer paper. This allows you to print images that are unique and have a collage feel to them.

If the pages you try don't work as well as you would like, you can coat them with a product called Digital Ground (made by Golden Artist Colors, Inc.), which will create a surface that allows you to print on almost any substrate that can be fed through your inkjet printer. For example, if you find that an image is dull or blurry, it likely means that the surface of the paper you are using is absorbing too much of the ink. The Digital Ground coating prevents this from happening. It even works on materials like acetate, plastic,

and metal, preventing the ink from pooling and running. This special coating only works with inkjet printers, not with laser printers. There are three kinds of Digital Ground available. The White Matte Digital Ground is porous, opaque, and white. Printer inks will dry fast, but because of the white background, you will not be able to see through to the layer underneath, which is often an undesired result if you are trying to create a collage effect. The Clear Gloss Digital Ground is clear with a gloss sheen that allows your underlying layers to show through. However, printer inks take a little longer to dry on the Clear Gloss coating, which can result in printer wheel marks on your printed page. There is also the Non-Porous Surfaces Digital Ground, which is similar to the Clear Gloss Digital Ground but is specially designed for non-porous surfaces such as plastic or aluminum.

Above: This image was printed on heavy-duty aluminum foil that had been primed with Digital Ground for Non-Porous Surfaces

With Digital Ground on your side, you can try printing on anything you are comfortable putting through your printer. My two favorite substrates are rice paper and foil. There are different types of Digital Ground coatings available for different substrate surfaces, so make sure you use the right one for the substrate you are working with. For rice paper, I use the Clear Gloss Digital Ground, and for the foil I use the Digital Ground for Non-Porous Surfaces.

Put down a sheet of plastic to protect your working surface. Then, using a foam brush, cover the surface of the substrate you wish to print on with two coats of Digital Ground. Brush the first coat horizontally across the surface. Once that coat is dry, brush the second coat on vertically. This ensures even coverage. Once the coating is completely dry, use masking tape to secure your substrate to a sheet of printer paper and run it through your printer. Some printers will leave printer wheel marks on delicate substrates like foil, but this can add a unique element to your image's texture.

(hint)

For more technical information about Golden Digital Grounds, visit: www.goldenpaints.com.

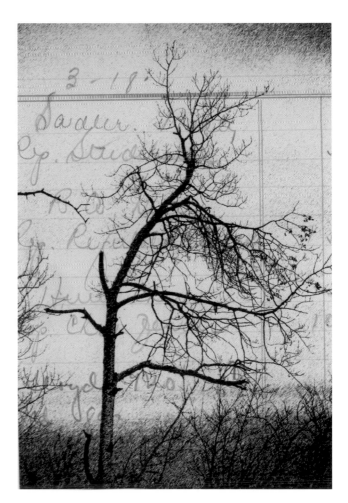

UNIQUE IMAGE PRESENTATION

Whoever said that a photo has to be displayed behind glass? Photographs are pretty sturdy and, unless you plan to have the same photograph hanging up for ten or twenty years, they do pretty well attached to backgrounds without any glass sandwiched over them. How you display your photographs gives you another opportunity to let people know who you are. Read through the next series of projects for some fun image-presentation ideas.

{ AT YOUR ART TABLE }

EXPLORATION 16
Framing with Old Book Covers

One of my favorite ways to display photographs is to add an interesting border in Photoshop, have the photo printed on photo paper, and attach it to the front of an old book cover. Books with cloth covers are particularly great for this. You can find them at thrift stores or library sales. Use a PVA (polyvinyl acetate) glue or double sided tape to attach your photograph to the book cover.

Punch two holes at the top of the book cover using a Crop-A-Dile II Big Bite™ or a Japanese screw punch. Then, thread fabric, ribbon, or string through the holes to hang your frame on a wall. You can also add embellishments to the book cover by punching more holes and tying on more ribbons or fabric, or you can glue on other embellishments.

UNIQUE PRINTERS

The Polaroid POGO printer is a device that allows you to print 2 x 3-inch (5.1 x7.6 cm) size photos on the go. You can transfer images directly from your camera into the printer, so it is an ideal gadget to take on the road. The images are printed on ZINK Photo Paper™, which stands for "zero ink."

The POGO prints have an artsy, printed-in-your-basement look to them. The colors are deeper and the images not quite as sharp as a photograph from a commercial photo lab. I often find that an image printed on the POGO printer can look more mysterious than a traditional print because of the darker color tones. The prints have an adhesive backing so they are easy to paste into a journal or onto a card or postcard and mail from your destination.

Prints from the POGO printer can be altered in a number of ways. For example, you can feed a print through twice to get a double exposure. You can also soak your POGO prints in water and remove the top section of color from your print. If you like experimenting, see what you can come up with to do with your POGO prints.

EXPLORATION 17
Creating Hanging Displays

Hanging photographs from a string using mini clothes pegs allows you to change them frequently so you have a constantly evolving and inspiring display of images. Add borders in Photoshop to create different looks, such as a pseudo-Polaroid framing, a filmstrip look, or burnt or torn edges. You can also use black or colored cardstock to create a background on which you attach your photograph and paste words cut out of magazines to inspire you. Having your photographs on display rather than hidden in an album or on a computer allows others to share in their beauty, and shows the world what you are passionate about.

As I particularly like small things, I often use slide holders as miniature frames for my photographs. I connect these together with split pins or jump rings. By adding ribbon to the sides, I can easily hang a string of these up at a window or bookshelf. You can resize your photographs to fit the slide holders, or use Photoshop Elements' Contact Sheet feature (found under the Print function) to automate resizing a number of images together.

The photographer projects himself into everything he sees, identifying himself with everything in order to know it and to feel it better. —Minor White

PHOTOGRAPHY AS SELF-EXPRESSION

Figure 2

Figure 3

Figure 4

Figure 5

Figure 6

Figure 7

EXPLORATION 18

Adding Artful Borders

I love using Photoshop to add borders to my images. There is no limit to the borders you can create. There are a couple of ways to create borders.

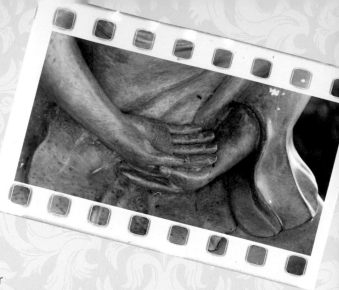

If you have any old photos with interesting edges, they can be scanned and then combined with your image in Photoshop. Almost anything can be scanned and used as a border. An obvious example of this is using an old negative.

Step 1: Scan your old image or negative at 300 ppi.

Step 2: Using the Rectangular Marquee tool, select the part of the image you would like to use as a frame, then crop that section out (figure 2) by going to Image > Crop.

Step 3: Again using the Rectangular Marquee tool, and making sure the background color is set to white, select the inside of the frame that you would like to delete. Once selected, use the Eraser tool on your selection (figure 3). The Eraser tool will only work within the selected area, so you will get a nice, straight edge.

Step 4: To darken or lighten the border you have created, go to Enhance > Adjust Lightings > Levels and move the sliders until you like the color of the frame (figure 4).

Step 5: Finally, you are ready to open an image you would like add the border to. Drag the scanned frame onto your image. You will see that they are not the same size (figure 5). Resize the frame by clicking and dragging the arrows around the border until the frame fits your image. By doing this we do not keep the scale of the frame, but usually proportion is not a problem with a frame.

Step 6: Go to the Blending Mode drop down menu at the top of the Layers Palette on the right of the screen and select the Multiply blending mode. This will allow the bottom layer to show through the top white layer (figure 6).

Step 7: You can also invert the frame (provided you are still working with separate layers) by going to Filter > Adjustments > Invert to get the effect illustrated in figure 7.

Step 8: Lastly, you can make further Levels adjustments on the frame layer if you choose.

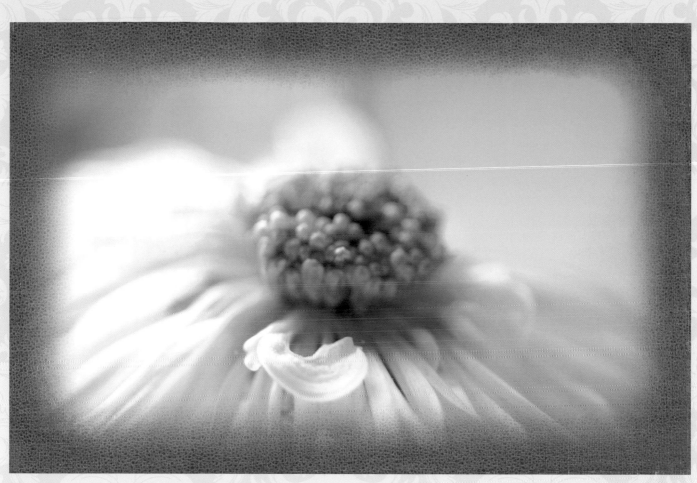

Figure 9

Another way to create a unique image border is to scan an object with an interesting look or texture, such as the cover of an old book.

Figure 8

Step 1: Scan the cover and use the Rectangular Marquee tool to select the inner portion that you don't want to include in your frame, using a feathered selection.

Step 2: Making sure your background color is set to white (via the box at the bottom left of the screen), use the Eraser tool to erase the selected section of the book-cover scan (figure 8).

Step 3: Go to Select > Inverse to select the outer edge, then drag and drop this frame-edge layer onto your chosen image.

Step 4: If you want to change the color of the frame, click on the frame layer and go to Enhance > Adjust Color > Adjust Hue and Saturation. Check the Colorize box and adjust the Hue slider to get a new border color (figure 9).

EXPLORATION 19
Creating Brush-Tool Borders

If you want to create a rough border around an image, the Brush tool is a good choice for achieving this effect. Open your image and click on the Brush tool. At the top of the page, make sure your Mode is set to Normal so you can get the most effect from the brush. However, you can also use the Mode setting to change the blending mode if you want to experiment with another effect. Make sure the foreground color (at the bottom left hand side of the screen) is set as black if you want your border to be black, or set at white if you want your border to be white.

Go back to the top of the screen and note that there are many Brush options to select from the dropdown menu, and you can also choose the size of your brush.

The size of your brush will depend on the size of your image. The larger your image, the larger the brush you will want to use, as the effect will not be very visible if your brush is too small. Remember that different brushes will give different effects. You can also reduce the opacity of the brush if you want to lighten the edges of your image.

Try using decorative brushes to create interesting edge effects. You can find a number of preset decorative brushes under Special Effect Brushes or Pen Pressure in the Brush dropdown menu. You can also make your own unique brushes. In fact, entire images can become brushes, as shown in the next exploration with the nautilus image.

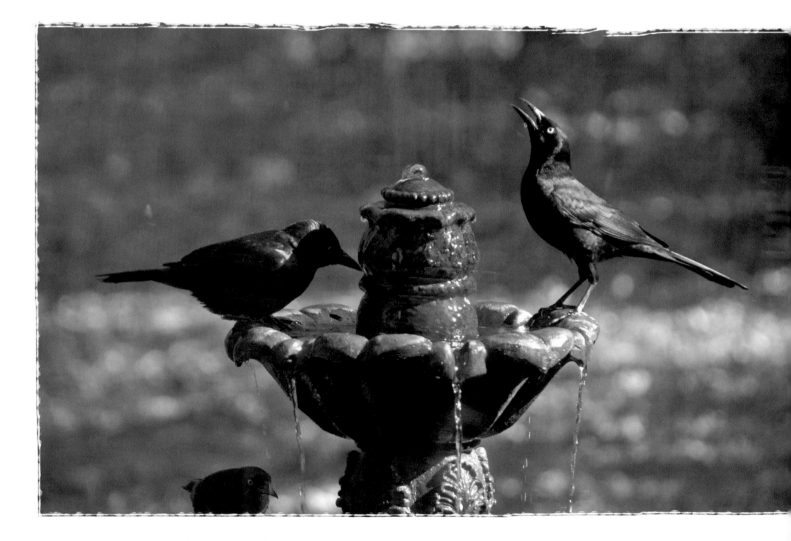

EXPLORATION 20
Making Your Own Brushes

Brushes act almost like rubber stamps, and making your own brushes is an incredibly easy to way to add some interest to your images. It is relatively simple, too.

Use a photograph or a scan of something that is copyright free. I chose to use this photograph of a slice of nautilus shell, which I resized so that the width was less than four inches. (Remember to make a duplicate layer so you are not affecting your original image.) I chose to invert my image because it was on a black background. (To invert, go to Filter > Adjustments > Invert or use the shortcut Ctrl+I.)

Next, I used the Lasso tool to select the area that I wanted to use as a brush—in this case, the entire nautilus shell. If you are selecting something that is not a specific design—such as a scan of some scratches that you intend to use to add an aged look to your image—it is a good idea to feather the edges of your selection. Once you have made your selection, go to Edit > Define Brush from Selection and give your brush a name. Your own specialized Brush tool will be saved under one of the palettes. Try your creation out on some images.

To size your brush, you can use the [key to make your brush smaller and the] key to make it larger. To rotate your brush, go to the menu at the top of the page and click on the paintbrush symbol, which represents options for setting brush dynamics. Once you click on this, you will get a dropdown menu with a number of selections you can explore. The Angle tool is the selection that allows you to rotate the brush.

If your foreground color is white, your brush stamp will be white. If the foreground color is black, your brush stamp will be black. If you need a deeper black, click the brush stamp a number of times without moving it and your brush stamp will get darker.

Creating brushes can become an addictive pastime, as the choices are endless. You can create brushes from any shape you wish to use. You can also turn text into a brush. Experiment and see what you can come up with.

REVEALING YOURSELF THROUGH IMAGES

Your images reveal to others who you are. They also reveal you to yourself. When we are in the picture, we can't see the entire view, and our photographs are a way for us to look from a distance at who we are. Be curious. Be willing to take risks. Ask questions. This will help you experiment and get past the fear of doing things in ways that are different than what you are used to.

{ WITH YOUR CAMERA }

EXPLORATION 21
A Legacy of Images

When you die, one of the ways that those left behind will know the essence of who you were is by what you created during your life. As Dorothea Lange (the well-known photographer who documented the migrant laborers during the Depression) said: "In a sense, your photographs are your autobiography." What photographs will you leave to tell your story?

Obviously, this is not a project you can do in a day, but start thinking about it. When you make a photograph that you think really expresses the essence of who you are, put it aside in a box. Journal about it, if that is helpful to you, and date the photographs so you can track your visual journey. These images can serve as a sort of retrospective that helps you to see where you have come from and who you have become.

We photographers are poets in the language of symbols. We crystallize experience, reflect the essence of a moment, convey raw and honest emotion with contrast instead of cadence, composition instead of rhyme, light and shadow instead of words. —Jan Phillips

Images unearthed are not merely random, they are metaphor. I am not creating something else. I am revealing who I am. —Catherine Moore

Photographing Your Inner Self

Many artists create self-portraits. I dislike having my photograph taken, so when my college photography professor told me I had to spend the whole semester creating self-portraits, I cringed and tried to get out of it. However, during this exploration, I discovered that a self-portrait didn't have to include my face. In a sense, every photograph is a self-portrait.

How would you choose to photograph yourself? Is the face you show the public a true reflection of who you really are inside? How do you think others see you? How would you like to be seen? What does your soul look like? You are more than your face. Express who you are. For this project, answer these questions with your photographs only. No words allowed.

Who am I?

What makes me smile?

What does my perfect morning look like?

If I could do anything right now, what would it be?

If I could be anything in this moment, what would I be?

What inspires me?

What nurtures me?

What is my secret dream?

Secret Vision Box

Create your own Secret Vision box that contains your answers to these questions. I made mine out of an old binoculars box, which I decorated with photo transfers and stickers. In addition, if you, like me, prefer to be behind the camera rather than in front of it, take this opportunity to consider becoming more comfortable being the subject of a photograph. Use your camera's self-timing feature to make self-portraits that include your face and your body. Let the camera be a tool that encourages you to become more contented with yourself.

> [Your] inherent color sense is not only personal but also part of a universal, elemental vocabulary that reflects all the elements of the natural world— the pervasive qualities of *earth, air, fire, and water.*
>
> —Connie Smith Siegel

HONING YOUR COLOR SENSE

We are surrounded by color, but we are so used to its place in our reality that we often don't notice it. However, I find that when I see one or two colors that really resonate with me, my vision is reawakened. Spring is an especially good time to notice color. The world seems covered with a blanket of bright green, peppered with bursts of vibrant color that demand my attention. And in autumn, the colors blend together in a way that speaks to my senses and I see rich displays of many hues that seem to be connected to each other.

Each color seems to have a unique voice, one that speaks to us on a subconscious level. You may find yourself drawn to certain colors at certain times. For example, I always turn to a red shirt when I am tired but need lots of energy. Colors have long been associated with different feelings, as one can see from the many color metaphors we use in our daily language: I feel blue, I'm green with envy, I saw red, it was a black day, and so on. When you see the colors of your country's flag or your school colors in a totally different context, you will unconsciously still see them as what they represent to you. Color association has become part of our emotional vocabulary.

In the chakra system, which has its origins in ancient Hindu culture, certain areas of the body are believed to have energy centers, each with a different vibration and color, and each relating to specific emotions. For example, the color green is the color of the heart chakra, and the color blue is associated with the throat chakra. Colors can be associated with memories. Color can express feelings that we cannot verbalize. I am sure there are certain colors that you associate with certain people in your life. In this way, colors can be symbols for something—or someone—else.

Helen Keller, who was deaf and blind, sensed colors with her body. Her description of color is particularly amazing, as she could not see color so she had to sense it in other ways: "I understand how scarlet can differ from crimson because I know that the smell of an orange is not the smell of a grapefruit. I can also conceive that colors have shades and guess what shades are. In smell and taste there are varieties not broad enough to be fundamental, so I call them shades[.] … The force of association drives me to say that white is exalted and pure, green is exuberant, red suggests love or shame or strength. Without color or its equivalent, life to me would be dark, barren, a vast blackness." Helen Keller's sense of color was heightened by her senses of smell and taste.

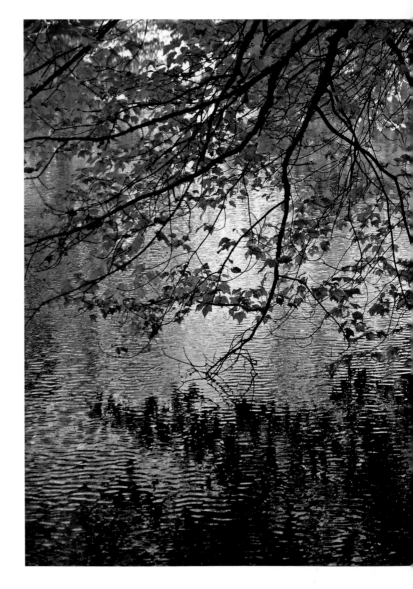

(hint) Look around your home. Do you surround yourself with colors that make you feel energetic and upbeat? If not, display some of your color photos around your home and see if you feel uplifted when you look at them.

THE EVER-CHANGING QUALITY OF LIGHT

Light constantly changes and moves. You will see this quite plainly if you photograph the same subject at regular intervals throughout the day. The type of light falling on an item changes the way we see it. This is why it is almost impossible to use natural light to take identical photographs on different days. It might be similar on another day, but it will never be exactly the same. Every photograph is touched by new light. Our eyes and brain have learned to adjust to changing light, and while we often don't perceive the subtle changes, the camera does.

Think about the light when you make a photograph. Think about where it is coming from, how it falls on your subject. Does it light your subject from behind, in front, or from the side? Which type of lighting do you like best? I like light that seems to illumine the edges of a subject. Take an hour in the early morning or early evening to sit and watch how the light changes as it moves across your room or garden. German philosopher Arthur Schopenhauer believed that "colors lie within the observer, and not outside him or her." I like this idea, as it encourages us to combine colors that appeal to us on an intuitive level, and we learn to trust our instincts more easily.

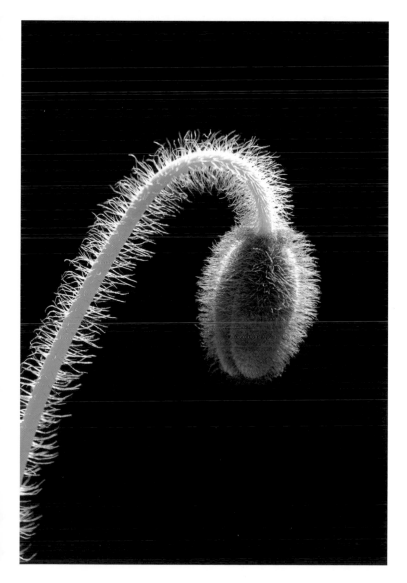

*I see the world around me made up of splinters of light. Photography allows me to arrange these splinters in a **kaleidoscope of possibilities**, yet no two the same. It's this light that will always inspire me. It's the light that unites us all. —Josie Borain*

THE EMOTION OF COLOR

COLOR TOOLS AND FILTERS

There are a number of digital-darkroom tools for adjusting the color of a photograph. In Photoshop Elements, most of these are found under Enhance > Adjust Color and Enhance > Adjust Lighting. Using these tools, we can improve or alter the color of our original photograph in several different ways.

Levels

Adjusting the Levels slider can improve the overall exposure of your image and give you a result that is brighter with more contrast. Using this tool alone will often improve the color of your image. (For more details about using the Levels tool, see page 20.)

Brightness/Contrast

This is another tool found under Enhance > Adjust Lighting that will allow you to change the brightness and contrast of your image. Two sliders appear together when you select the tool, and you can move them left or right to decrease

or increase the effect. As with the Levels adjustments, you will notice that the Brightness and Contrast adjustments also affect the appearance of the colors in your image.

Hue/Saturation

You can make the colors of your images more intense by boosting saturation. You can also alter the hue of the colors.

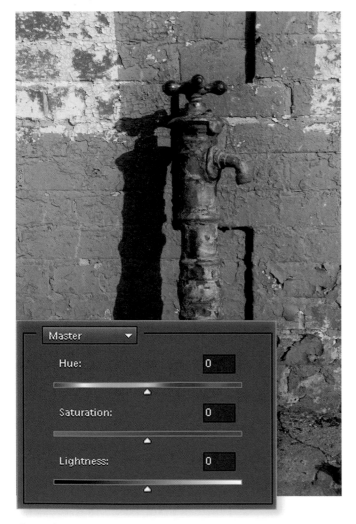

Original image

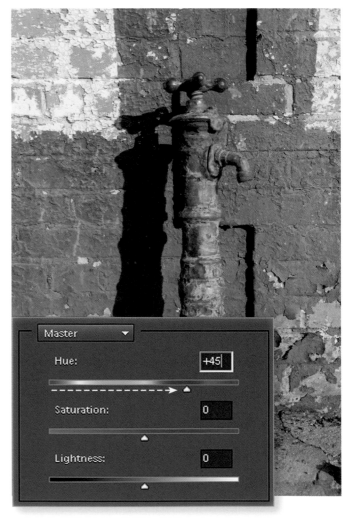

Image with Hue adjusted

The best way to see the multiple variations that these tools offer is by playing with the sliders for each option. To experiment with them, go to Enhance > Adjust Color > Adjust Hue/Saturation. Make sure you save any variations you like under a new name so that your original image is not affected.

You can get some unusual results using the Hue slider. It can make your image look pretty psychedelic, if you choose! And the Saturation slider can enable you to achieve effects from complete desaturation—turning your image into black and white—to over-the-top color. The best way to discover new color combinations is by experimentation and observation.

The mission of art is to bring out the unfamiliar from the most familiar. —Kahlil Gibran

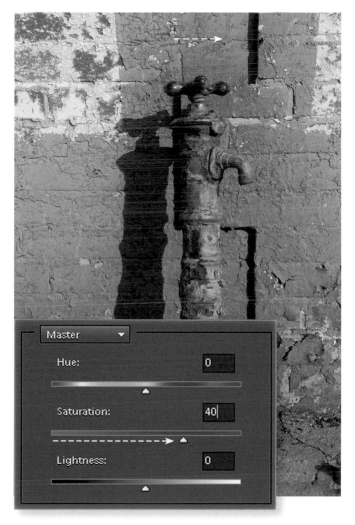

Saturation increased

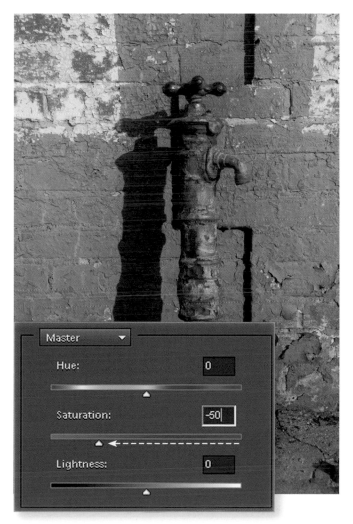

Saturation decreased

THE EMOTION OF COLOR

EXPLORATION 1
Quick Pop Art

Using the Hue slider, you can create an image reminiscent of the Pop Art style. Open your chosen image in Photoshop Elements, make a copy, then select Enhance > Adjust Color > Adjust Hue/Saturation. Adjust the Hue slider slowly to the left or right and watch how the colors of the image change. When you are happy with the look you have created, save the changes. Repeat the process several times until you have multiple renditions of the same image in a selection of vivid colors. You can then move your images into one document in an arrangement that looks good to you.

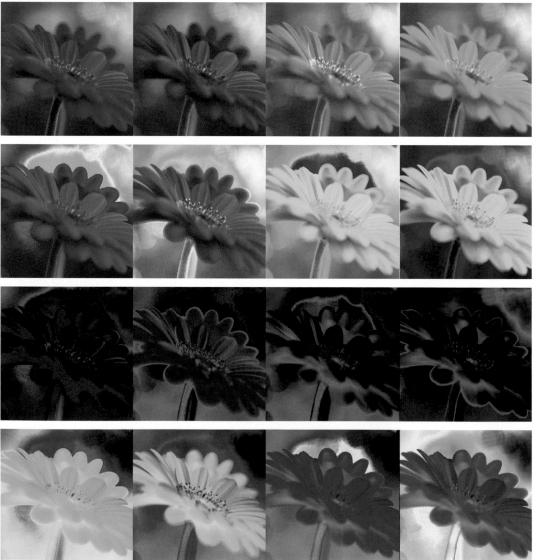

I created this Pop-Art-style piece with a moderate increase of Hue and Saturation values.

Here, I boosted Hue and Saturation even more.

Next, I applied the Solarize filter, found in the Filter > Stylize menu.

Lastly, I tried out the Invert filter, found in the Filter > Adjustments menu.

EXPLORATION 2
Collecting Colors

There is magic and mystery in colors. I love the way two blues or two reds are never quite exactly the same. Color seems to be an ancient language with a vocabulary that speaks to our subconscious. It is a language we all speak.

Start scanning your surroundings for images that contain the colors of the rainbow: red, orange, yellow, green, blue, and purple. Look for all shades and hues of these colors. Look for them in the natural world as well as in urban areas and manmade things. Look in your house. Set up a color still life. Photograph colors wherever you see them and start color folders on your computer to keep track of the color images as you find them.

The idea is to create photographs of each of these colors individually so that you have a selection of images in each color. And you don't have to stay within the colors of the rainbow; colors like pink or turquoise may be a little more difficult to find, but the more you train your eye to find a certain color, the more you will start noticing splashes of that color in your surroundings.

I like to focus on one color at a time, but you can also look for them simultaneously. Go to your local farmers market; fruits and vegetables make amazing color photos. Bring back a container of raspberries from the supermarket, and before you eat them, photograph them. Think of all the places you can find color and make photographs to add to your collection.

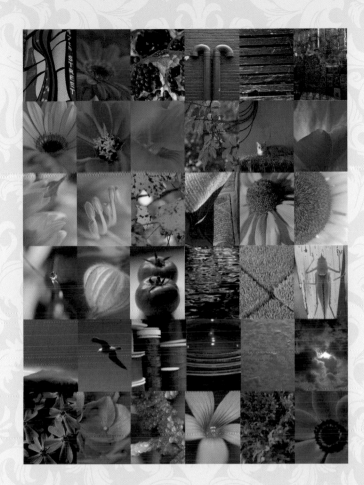

I found I could say things with color and shapes that I couldn't say any other way—things I had no words for. —Georgia O'Keeffe

A quick and easy way to create a colorful book is to use paint color chip samples as your background pages. Size your images to fit the strips, glue them on, and you have a book.

THE EMOTION OF COLOR

EXPLORATION 3
Mini Accordion Star Book

To make a small book to display your color photographs, start with 12 x12-inch (30.6 x 30.6-cm) sheets of red, orange, yellow, green, blue, and purple cardstock. Cut each sheet into three strips that are 4 x 12 inches (10.2 x 30.6 cm) in size. This will be enough to make two books (or one very long book). I then use a scoring board tool to score the 4 x 12-inch (10.2 x 30.6-cm) strips at 3-inch (7.5-cm) intervals. This creates four sections on each

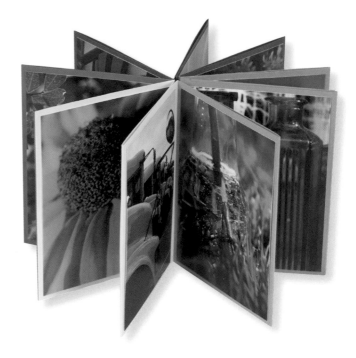

strip. Scoring the cardstock makes it easy to fold. If you do not have a scoring board, fold the cardstock in half, then in half again (to create quarter folds). Use a bone folder to make a professional crease. Do this for each colored piece of cardstock.

Use glue or double-sided tape to join the colored cardstock in a rainbow sequence (red, orange, yellow, green, blue, and purple). When you join the color strips, glue or tape the end of one color section onto the beginning of the next.

When you reach the last strip, attach the last color back to the first one to create a continuous, star-like display of your color photographs. Alternatively, you could keep the book in a landscape orientation (by not securing the last color back to the first), then attach a hanger and hang the book up for display.

Size your photographs according to the size of the finished mini book pages. I sized my photos to be 3 x 4 inches (7.5 x 10.2 cm), then used my paper cutter to trim them down a little so that part of the colored cardstock showed around the edges.

EXPLORATION 4
Rainbow Diagonal Book

If you have collected a large number of color photographs and are feeling adventurous, this rainbow diagonal book is a fun way to display your images. To make the book, you will need 12 x 12-inch (30.6 x 30.6-cm) sheets of cardstock in red, orange, yellow, green, blue, and purple. Fold each sheet into quarters (fold them in half, then open them up and fold them in half the other way). Use a bone folder to score the folds. Next, fold each sheet diagonally in half so you have two triangles. Score the diagonal fold. Take hold of the corners of the cardstock where you folded the sheet diagonally and push these corners in and towards you. As you do this, these triangular bits will move inward so that the whole sheet is folded as a square again. Score the folded square edges. Do this to all the sheets of cardstock.

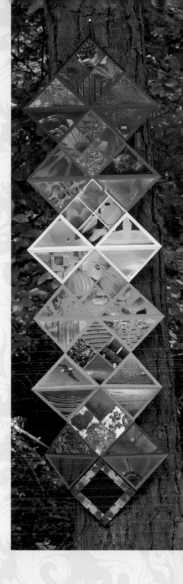

Once you have folded all the sheets in this way, lay them out with each subsequent color sheet overlapping the bottom portion of the previous sheet. Layer the colors in rainbow order. Use double-sided tape to tape each sheet onto the previous sheet.

Left: Your cover will look like this once you have glued on the cover paper and cut the corners at an angle. The next step would be to fold the edges of the cover paper and glue or tape them in place.

To make the covers, cut two pieces of cardboard about 1/4 inch larger all around than your finished book size. The book illustrated here measured 6 x 6 inches (15.2 x 15.2 cm), so my cover cardboard was about 6.5 inches (16.5 cm) square.

Next, cut paper to cover the cardboard. It should be about one inch (3.2 cm) larger than cardboard. I like using black paper, as this creates a good base for any additional images I might choose as embellishment for the cover. Glue the cover paper to the cardboard and cut the corners at an angle so you get rid of any excess paper that is not needed once you fold your cover paper over. Fold the edges of the cover paper and glue them into place. Place double-sided tape on the outside corners of the red and purple papers and adhere these to the covers. Decorate your cover with a collage of some of your favorite color photographs, choosing one from each rainbow color.

THE EMOTION OF COLOR

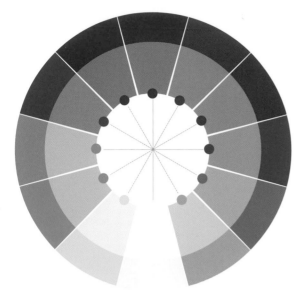

COLOR COMBINATIONS

Just as single colors can stir up feelings and associations, so, too, can color combinations. There are a lot of rules pertaining to the color wheel, but I'd like you to start looking for color combinations in the world around you and let your body tell you whether they resonate with you. Color combinations change a little like fashion. I'm sure the Victorians would never have thought of combining bright orange and shocking pink, yet I see that color combination frequently. Learn to discern how the color combinations make you feel. Do certain combinations feel soft while others feel strong? Contrasting colors are found on opposite sides of the color wheel and often have a bold feel to them when they are seen together. Harmonizing colors are usually adjacent to each other on the color wheel. Do you prefer subtle, gentle colors or strong, bold ones? The following projects incorporate these thoughts and ideas.

A color wheel is a graphical representation of color hues, with complementary colors directly opposite each other on the wheel.

The work will wait while you show the child the rainbow—but the rainbow may not wait. —Unknown

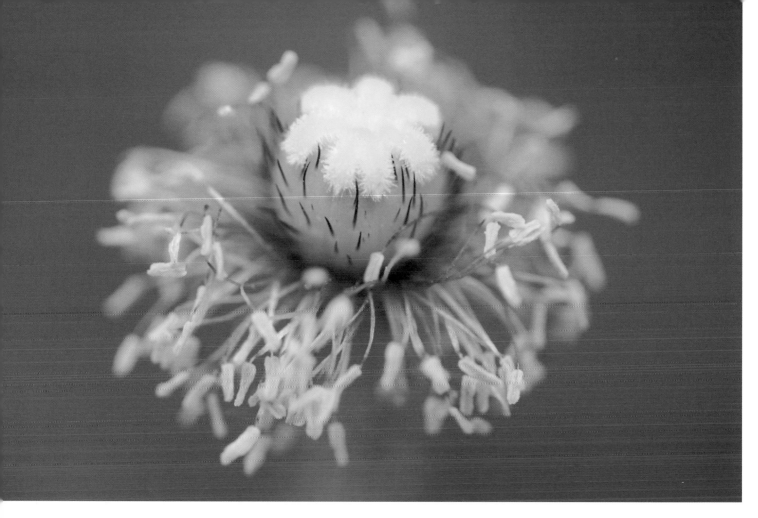

{ WITH YOUR CAMERA }

EXPLORATION 5

Seeing Color Relationships

Look for contrasting colors and harmonizing colors. Don't let the color wheel determine what color combinations to look for. Go with your own feeling of whether the colors feel strong or soft together. Look for unusual color combinations and find colors that appeal to your senses. They don't have to be bright colors. They can be muted and pale, or they can be neutral colors. Look to nature for inspiration.

THE EMOTION OF COLOR

Exploring Background Colors

If you are photographing flowers, your image will be more striking if the background is out of focus. Selective focus allows the viewer's eye to be drawn to the part of the image that you most want to emphasize. To get an out-of-focus background, set your camera on to its Aperture Priority mode (if available) and set your f/stop to f/5.6 or lower to create a shallow depth of field. (Refer back to page 17 for more information.) If the background you're shooting against is not what you had in mind, consider creating your own color backgrounds using colored poster board. This allows you to create a color combination of your choosing between your subject and the background.

Black makes a simple and striking background, eliminating distractions and making the object you are photographing stand out. My favorite black backdrop is black velvet cloth. It is important to make sure there are no white flecks on your background, as they will often show in the photo. Use a lint roller before placing your item on the background. If you still find some flecks in your final image, you can use the Clone/Stamp tool to clone a clean part of the background and stamp it over the unsightly flecks. White backgrounds can also be very powerful if you want to isolate the object you are photographing but want a softer feel than you might get with a black backdrop.

Experiment with photographing objects against different backgrounds. This exercise will help you learn more about your perception of color combinations, as well as making you more aware of the colors of the objects/subjects you are photographing. It is important to be aware of everything that falls within the frame.

<div style="float:left">{ WITH YOUR CAMERA }</div>

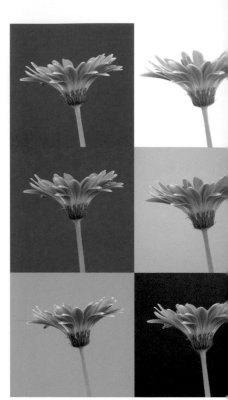

Above: I used masking tape to attach poster board to the wall outside my studio door, placed the pot of gerbera daisies in front, and played with different color backdrops so I could see what combinations I liked.

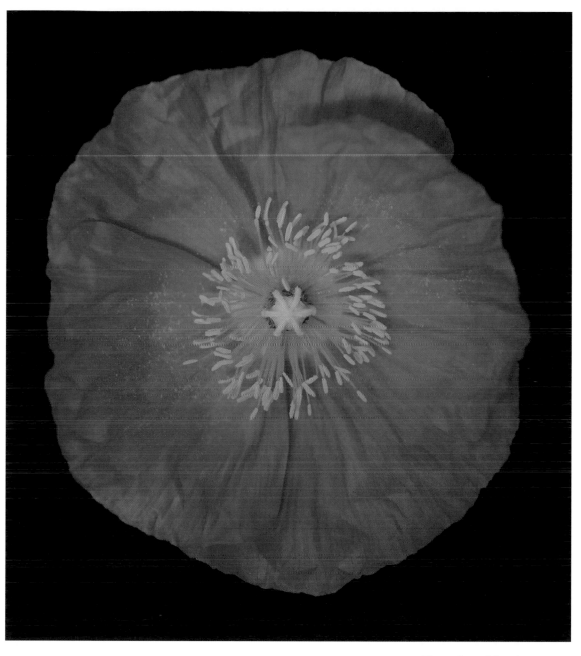

Above: One of the advantages of a solid background is that you can easily use the Magic Wand tool to extract the item from it.

Left: These cherries would have looked very different if the person holding them had been wearing a blue or green skirt instead of a red skirt.

Color is a language by itself. —Ernst Haas

THE EMOTION OF COLOR

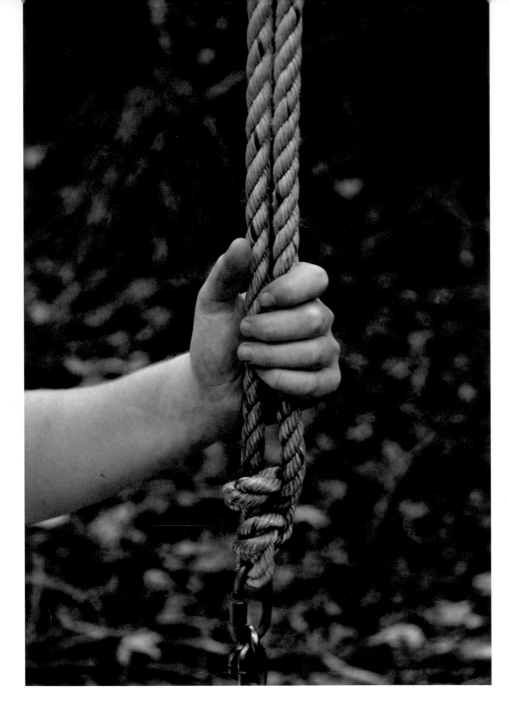

The original image (top) started as a rather washed-out neutral. I layered on a faded vintage photograph I had scanned (bottom), reduced the opacity of this layer to 60%, and used the Color Burn blending mode to achieve the rich shades of brown seen in the final image (left).

EXPLORATION 7
Shades of Neutral

Some of my favorite colors are the neutral shades, the browns and beiges. When you are photographing similar shades, the secret to creating an effective image is to focus on different textures and shapes. In addition, experiment with the Color Burn blending mode, which deepens colors.

EXPLORATION 8

Shades of White

As you may have discovered when you collected your color photos, you can create a powerful image that contains only similar shades or tones of one color. In photographs such as these, the shapes and forms in the image become more important. I find these images gentle on the eye but also very moody and evocative.

Learning to look for shades of white is different from looking for colors, although white is really a combination of all the colors contained in the visible light spectrum. So, in effect, it is the complete energy of light. As the poet Gilbert Keith Chesterton said:

"White … is not a mere absence of color;
It is a shining and affirmative thing,
As fierce as red, as definite as black …
God paints in many colors;
but He never paints so gorgeously,
I had almost said so gaudily,
as when He paints in white."

Even with very little color, a monochromatic white image can make a powerful statement.

To find pure white is almost impossible, so think of white as having shades, such as cream, beige, and off-white. Some whites contain hints of blue, green, or pink. Snow, in particular, can have a blue hue to it.

We often disregard white shades because they tend to blend into the background. But, when white is contrasted with dark shadows, it can create a moody feel to an image. Think of all the ways you can photograph white—winter snow, dandelions, seashells, bed sheets—and experiment to see what emotions your compositions can evoke.

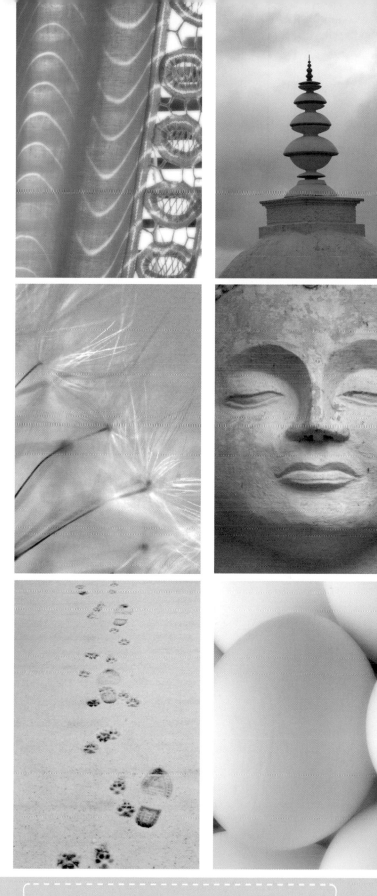

THE EMOTION OF COLOR

EXPLORATION 9
Shades of Black

When photography was first invented, photographs could only be made in black and white. Now, we have so many other options, and we don't even need to decide on how to render the color in our image before taking the photograph. We can apply in-camera processing after capture, or alter the image later using image-processing software.

Any color photograph can be converted to black and white. However, when you actually photograph in black and white, you need to interpret your scene more carefully before you take your photograph. The design of your image becomes more important. What shapes, lines, and forms will the tones of black and white create?

To get a good black-and-white photograph, you need to be more conscious of the contrasts between dark and light; you need to train your eye to see the way the camera sees. A composition that is simple and has strong lines, contrast, and texture will generally make a good black-and-white image. The impact of the image will come from the contrast of visible shades, so be aware of bright and dark areas in the scene you are photographing. Notice the way the light falls on your composition. Color is not always necessary to provide a powerful image.

CONVERTING IMAGES TO BLACK AND WHITE

There is more than one way to convert your image to black and white in Photoshop. One way is to use the Enhance > Convert to Black and White selection. Remember to make a duplicate layer of your image first and ensure that you have used the Levels controls to your photograph's best advantage. This will brighten the lights and darken the darks and create more contrast. In Enhance > Convert to Black and White, you are given the option of different styles of black and white and sliders to adjust the contrast and tone. This screen also allows you to compare your original color photo with the black-and-white photo, so you can see at a glance whether converting your image to black and white strengthens it or not.

An even easier way of converting your image to black and white is to use the Effects palette. This doesn't give you as much control over your final image as the previously described method does, but it is quick and easy. The Effects palette is on the top right-hand side of your screen and contains many automated ways to alter your images. If you double click on any of the Effects selections, that effect will be applied to your image.

TONING YOUR IMAGES

If you like the simplicity of black and white but would like to try something a little different, explore some of the other tones that you can find in the Effects palette. These can add mood to your image and make it look very different from the original. The Effects palette allows you to quickly turn your image into blue, green, purple, red, or sepia monochromatic tones.

If these presets don't give you the exact color you would like, you can create your own tints by using Enhance > Adjust Color > Adjust Hue and Saturation. Check the Colorize box in the bottom right-hand corner, then move the sliders to see what different tones you can create.

Looking at everything as if for the first time reveals the commonplace to be utterly incredible, if only we can be alive to the newness of it.
—Ruth Bernhard

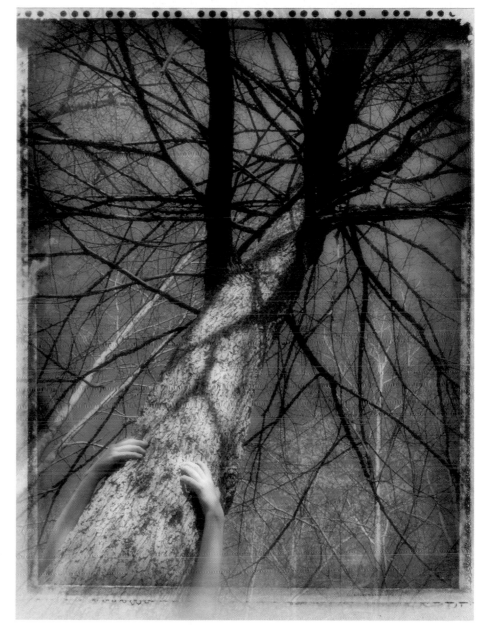

Black & White

Sepia Tint

Blue Tint

Green Tint

Purple Tint

Red Tint

THE EMOTION OF COLOR

ADDING COLOR TO BLACK-AND-WHITE IMAGES

There are times when you will want a part of a photograph to really stand out, and this technique is a perfect way to achieve that. Adding a hint of bright color to a toned or black-and-white photograph creates interest and allows a focal point to stand out. To do this, make a duplicate layer of your image and convert this top layer to black and white (Enhance > Convert to Black and White). Then, take the Eraser tool and slowly and carefully start erasing over the area where you wish to reveal the color layer below. Adjust the size of the eraser as you go to work carefully in the smallest parts of the area you are revealing. It does take time to do this accurately, but the results can be quite powerful.

(hint)

In some software programs, you may have to save your image as a new black-and-white image and layer that over your original color image to achieve this effect.

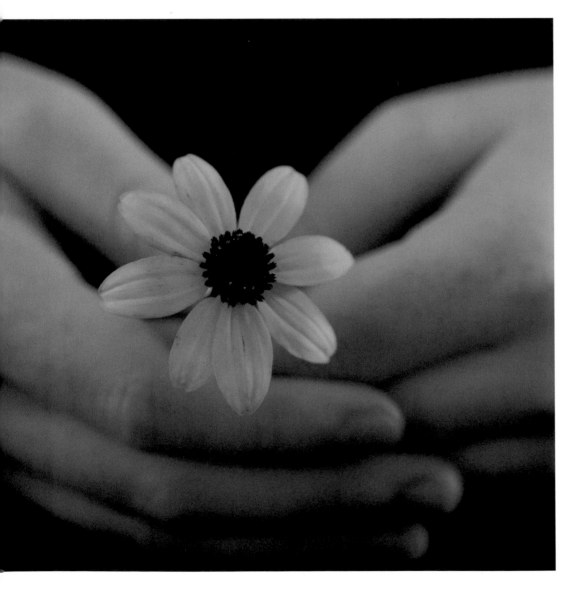

Above: Here you can see that I am part way through erasing the top layer of black-and-white to reveal the color of the flower in the layer below.

Light, that first phenomenon of the world, reveals to us the spirit and living soul of the world through color.
—Johannes Itten

IMAGINARY COLOR

Sometimes, we want our photographs to reflect our imagination, where colors can be more intense and vivid, and natural objects can be any color. One of the many ways to do this is to apply a layer of muted color over your original image then use the Color Dodge blending mode. You will get different effects depending on the color of the new layer. The effects can be quite extreme, but by reducing the opacity of the Color Dodge layer to around 40%, you can get a truly magical effect as the original image shows through. Experimentation will help you create unusual and unique "imaginary color" images. Let your imagination loose!

Color is the place where our spirits and the universe meet.
— Paul Cezanne

Right: The top photo is my original image; the middle panel is the muted-color layer I applied over the original; the bottom photo is the combined image with the Color Dodge blending mode applied at 100%.

Below: For my final rendition of the image, I lowered the opacity of the Color Dodge layer to 40%.

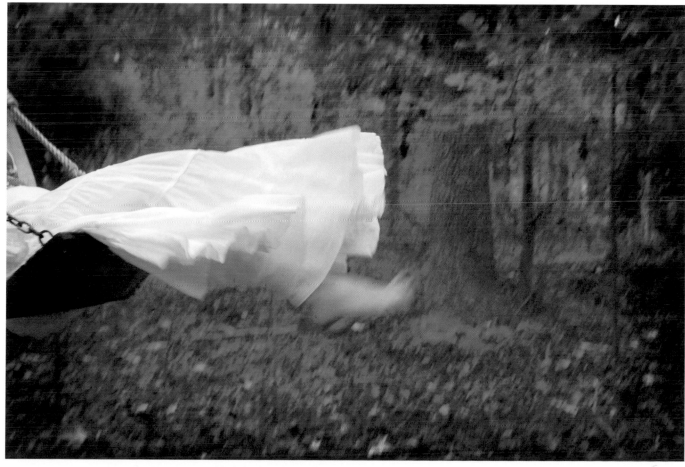

THE EMOTION OF COLOR

Photography concentrates one's eye on the superficial. ... [I]t obscures the hidden life which glimmers through the outlines of things like a play of light and shade. One can't catch that even with the sharpest lens. One has to grope for it by feeling.
—Franz Kafka

LOOKING WITHIN: SEEING FURTHER

What is it about closed doors that fascinates us? Doors can be metaphors for openings, closings, beginnings, endings; doors can symbolize thresholds, starting points for something new in your life; they can be portals or gateways to change. These are just some of the subconscious messages doors can convey. Every door has its own story. What is behind the door? What story does this one tell?

Doors also say a lot about culture and history. The doors in the image at left were photographed in New Orleans before Hurricane Katrina. They may no longer be there. To me, they tell the story of a time in history when individual handcraft was appreciated, when things were not mass-produced. They tell me of people who wanted to pass through beauty as they entered their home. The doors I photographed in Africa tell very different stories, as do the doors in France, as do the doors in my neighborhood.

Philosopher and poet John O'Donohue says this about doorways: "At any time you can ask yourself: At which threshold am I now standing? At this time in my life, what am I leaving? Where am I about to enter? What is preventing me from crossing my next threshold? What gift would enable me to do it? A threshold is not a simple boundary; it is a frontier that divides two different territories, rhythms, and atmospheres."

It is no wonder that we intuitively know that doorways have a symbolic significance in our lives. Doorways are thresholds to our inner and outer realities. They keep us in or out. They allow us to enter or leave. They are more than wood and metal and paint. As you learn to see the world more deeply through your camera, you will notice that everything is speaking to you. Your camera is a tool for rediscovering the world outside—and inside—your door.

TRANSPARENCY TRANSPARENCY CALIFORNIA

TRANSPARENCY TRANSPARENCY BEYNAC, FRANCE

TRANSPARENCY TRANSPARENCY SOUTH AFRICA

DOORS OF KWAZULU-NATAL, SOUTH AFRICA

A photograph is an instrument of love and revelation that must see beneath the surfaces and record the qualities of nature and humanity which live in all things. —Ansel Adams

EXPLORATION 1
Inside and Out

Windows are not only for letting light in, but also for looking out. Start noticing what is outside your window. Set your exposure for the view outside. Use the inside walls and window structure to create a dark frame for the image, which tells the viewer you were inside looking out.

Choose one or two windows in your home and take photographs looking out of them each season or once a month. Start noticing the small changes that happen right outside your window. You could even do this on a daily basis and see if you can notice the world changing from autumn to winter. Does it happen in one day, or does it happen day by day? These otherwise imperceptible changes occur in every area of our lives, and photography is a way to document them.

EXPLORATION 2
Beyond the Doors

By cutting open the doors in your photographs, you can show everyone what is behind them. Imagine what was behind the door and create your own scene. Make a 5 x 7-inch (12.7 x 17.8-cm) photographic print of a door that you particularly like and glue a sheet of colored paper or cardstock (I like to use black) onto the back. Then, when the photo door swings open, the viewer sees the color you glued on rather than the back of the photo paper.

Next, lay the photograph on a cutting mat (so you don't scratch your table surface) and use a metal ruler and a sharp craft knife to cut carefully along the edges of the door that you want to open. Where you cut will depend on the design of your door. For the image at right, I started with the center panels of the door and then cut the bottom of the door.

Cutting curves requires a little more concentration since you can't use a ruler as a guide. A sharp pair of scissors works best for this.

Once you have the door cut, fold the openings back and use glue or double-sided tape to attach another photograph or a quotation behind the opening so that it shows clearly through. Finally, attach both layers to a canvas panel. You can display this on a small easel or attach a hanger to the back so it can hang on a wall. You can also attach the finished item to a card and use it as a special greeting card.

{ PHOTOGRAPHIC INSIGHT }

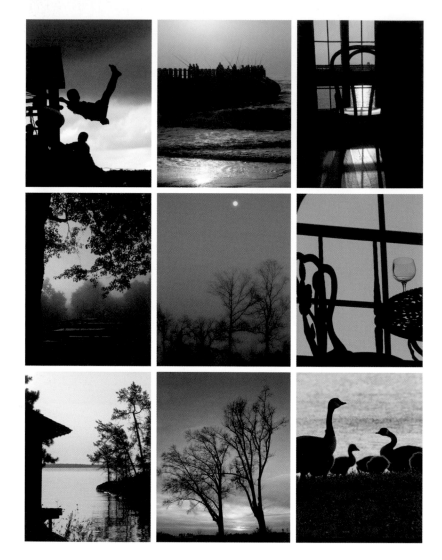

SILHOUETTES

Silhouettes are created when a subject is strongly backlit. When you photograph such a subject, it becomes black against the lighter background. The bright background creates the silhouette by virtue of the contrast in the image.

Silhouettes are more easily found—or created—at certain times of the day, such as sunrise or dusk, when the sun is lower in the sky and naturally falls behind our subject. To create an impressive silhouette, include a subject that has a distinctive, easily recognized shape and set it against a clear background, such as the sky.

You can also create your own silhouette photographs without the help of the sun by placing a lamp or a candle behind your subject. Find a bare wall in your home and set up a light in front of it. Then place the subject you want to photograph directly between the light source and your camera. Be sure to turn off the automatic flash feature of your camera so that it will read the exposure for the brightly lit background and cast your subject into silhouette.

If, in trying this technique, you find that the subject is not dark enough (i.e., you can still see some subject detail), try putting your camera into Manual mode and adjust the settings until you find one that gives you the silhouette effect you want. You can also take your photo into your image-processing software and use the Levels adjustment described in the next exploration to improve the silhouette effect. However, it is always best to try and get the image you want in-camera when possible.

EXPLORATION 3
Layering Silhouettes

This exercise makes me feel like an artist. When you first try this, I recommend that you find a photograph that is already a silhouette, or one that has a lot of black, so you can easily turn it into a silhouette.

Step 1: An "almost-silhouette" image can be turned into a silhouette by further darkening the subject. Go to Enhance > Adjust Lighting > Levels and move the black-tones slider to the right until your subject looks dark enough.

Step 2: Once your image has a strong, black silhouette, click on any portion of the black color with the Magic Wand tool. The tool will select everything of a similar color, so the entire silhouette should be automatically selected.

Step 3: Next, use the Move tool to drag and drop the selected subject onto a new background. Experiment with different things. I have painted on paper and scanned it into the computer, or scanned vintage papers for use as a background. Other photographs will also work well as a new background. This is a perfect opportunity for you to play and explore your options.

(note) Not all photographs are suitable for silhouettes layering. Make sure the image you are using has a strong subject and a clear background to make it easy to select and move onto another background layer.

PHOTOGRAPHIC INSIGHT

EXPLORATION 4
National Geographic Magazine Backgrounds

I love this easy and inexpensive way to create unique backgrounds for layered images. It involves using photographs and recycling at the same time. To do this technique, your will need full strength Valencia Orange CitraSolv® Concentrate solvent, which you can find in the cleaning section of most grocery stores. Once you have created these backgrounds, you can scan them and manipulate them further using the Hue/Saturation sliders, the Invert option, or any other image-processing filters or tools.

Step 1: Find some old *National Geographic* magazines, making sure that they are issues that were printed on glossy paper. Select a few pages with interesting colors.

Step 2: Make sure the room you are working in is well-ventilated and use a foam brush to generously cover the pages you selected with the CitraSolv® Concentrate. The more you saturate the pages, the more the inks move around on the page. You can place the pages on top of each other (if you have torn them out of the magazine) so that the CitraSolv® from the top pages is absorbed into the other pages.

(hint) CitraSolv® has some online videos illustrating this technique on the company's website: www.citra-solv.com/newcitraartist.

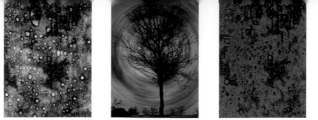

Above (left to right): Original scanned CitraSolv® page; Radial Blur Filter applied; Solarize Filter applied

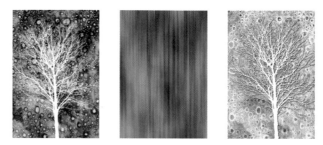

Above (left to right): Colorize and Hue/Saturation applied; Motion Blur Filter applied; Invert action and Hue/Saturation applied

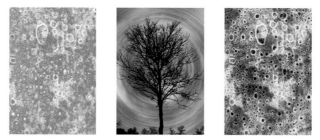

Above (left to right): Solarize and Invert applied; Invert and Radial Blur Filter applied; Invert action applied

Step 3: Leave the pages to absorb the solvent for approximately 10 – 20 minutes. After ten minutes, you can check to see if the inks have started dissolving. If you leave the pages too long, they will start sticking together.

Step 4: Place newspaper over your work area, separate your pages, place them on the newspaper, and leave them for a couple of hours to dry.

Step 5: Scan your favorite pages into the computer and use them as backgrounds for your silhouette images (see page 91). Each page will be different. The results are totally unpredictable. You may like a portion of a page but not the whole thing. That's okay; you can just scan the part you like.

EXPLORATION 5
Playing with Layers

I often think of layering as a form of digital double exposure. And, with the capabilities of software programs like Photoshop Elements, we can choose which portions of each layer will show in our final composition, and to what degree.

You can erase portions of a layer or change the opacity to make the layer less visible. You can also use one of the blending modes, which allow background layers to become more or less visible in different ways.

Before altering anything on one of my images, I always make a duplicate layer. This means my original photograph is still there under all the layers and I can refer back to it to see if I like the changes I am making. If you save your document as a JPEG, the layers will automatically be combined. However, if you save as a Photoshop document (PSD) or a TIFF file, your layers will remain intact, allowing you to return at any time to adjust them.

To begin experimenting with Photoshop Layers, choose two images that you would like to combine. Make sure that both your images are the same size and resolution,

resizing if necessary. Using the Move tool, I drag one image on top of the other image, creating a new image layer. Holding down the Shift key while using the Move tool will line up your images exactly. The top layer will initially obscure the bottom layer from view, as it is at 100% opacity by default.

One way of allowing the underneath layer to show through is by reducing the opacity of the top layer. To do this, make sure you have selected the top layer or you will not see the desired effect. For the example illustrated here, I lowered the Opacity slider to 28%. Anywhere between 20% and 30% will give a good effect.

Another way to combine your layers is through the automated blending modes Photoshop offers. The Blending Mode dropdown selector is set to Normal by default, which means that no blending mode is applied. I selected the Darker Color mode for the example below. The effects of any of the modes will depend on the particular images you are using, so experiment with them all.

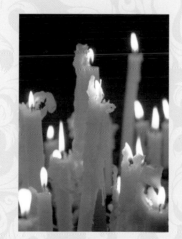

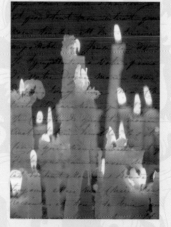

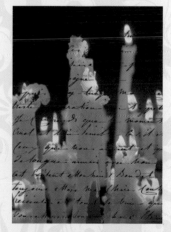

I selected these two images for use in my layering experiment.

Here are the layered images with the opacity of the top layer reduced to allow the bottom layer to show through.

Then, I applied the Darker Color blending mode.

PHOTOGRAPHIC INSIGHT

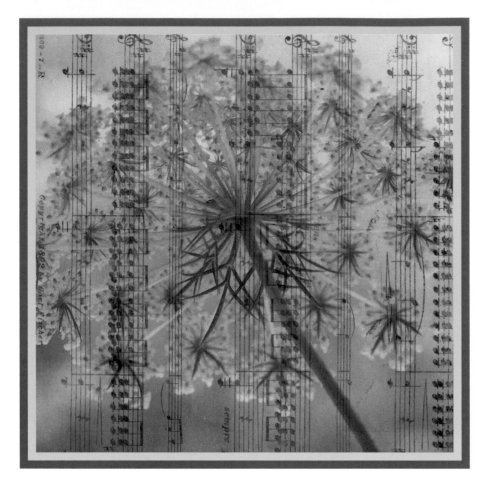

Once your tissue is printed, find a background layer that adds some interest to your image. You could even use your journal as the background layer and paste the tissue over your writing so some of it will still show through. Be very careful as you remove the tissue from the carrier paper. Carefully peel or cut off the masking tape. Then, using Golden Matte Medium, cover your entire background layer. Carefully place your printed tissue down on top of the wet medium. Do this slowly so there are not too many wrinkles (unless you want to make wrinkles for more texture). If you have enough matte medium on the background layer, the tissue should adhere just fine. If not, wait until the image has dried, then paint another layer of matte medium over the top. Don't add more while the tissue is still wet or it might tear.

EXPLORATION 6
Layering with Art Tissue

Another way of creating a layered effect is using art tissue. This is similar to tissue paper and can be purchased at most craft stores. It is a little sturdier than regular tissue paper but must still be treated gently as it can tear easily.

You can print directly on art tissue from your printer. To do this, cut a piece of tissue a little smaller than a letter-size sheet of printer paper. I recommend ironing the tissue with an iron on medium heat if is wrinkled. Next, using masking tape or blue painter's tape, attach the tissue to a sheet of letter-size printer paper (which will act as your carrier sheet). Make sure that the shiny side of the tissue is facing upwards. This side prints better than the other side, which has a matte texture.

EXPLORATION 7

Using Packing Tape to Create Transfers

This is an extremely inexpensive way to make transparent layers and it can become an addictive pastime. The packing tape transfers work really well in black and white. (See page 96 for instructions on how to create an ideal image for this project.) You can also use color images made on a laser printer or photocopier, but keep in mind that dark colors are not as transparent.

Packing tape comes in various thicknesses and widths. The easiest kinds to find are the two-inch (5.1-cm) or three-inch (7.6-cm) wide tape. I prefer the thickest tape (the 2.6 mil density), as it does not tend to crease as you place it on top of your image and it does not tear easily.

Size your images so that they fit on the width of the packing tape. Print out a sheet of these images on a laser printer or photocopier using plain copy or printer paper, not a special photographic or matte paper.

Cover the image with packing tape and burnish the image with something that will not tear a hole in the tape. I use the side of a bone folder, my thumb, or the handle of a pair of scissors. Make sure the entire image is well burnished. This adheres the paper to the tape so that the dark colors will transfer on to the tape. Next, place the paper attached to the tape into water for about five minutes. Remove it from the water and, using your thumb and fingers, rub the paper off of the back of the packing tape. The ink adheres the image to the tape and the paper rubs off. Once the paper is removed, dry the tape transfer on a paper towel if it is still wet. It is then ready to be placed over another image or background paper, or directly into your journal. Use an all-purpose craft glue to glue the tape transfer onto your chosen background.

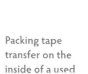

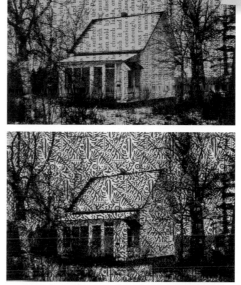

Packing tape transfer on vintage paper

Packing tape transfer on the inside of a used security envelope

Packing tape transfer on painted tissue paper; sections of white in the background are because I didn't rub all the excess paper off the back

You will notice some lines on this transfer. Getting impatient, I used a scouring pad to take off the paper. This is not a good idea, unless you are very gentle.

(note)

These transfers do not work with inkjet prints.

{ PHOTOGRAPHIC INSIGHT }

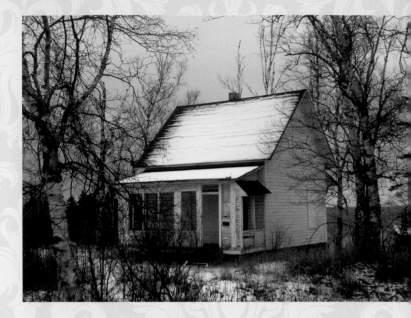

Creating Drawings from Photographs

To create images that will work very well with the packing tape transfer method detailed on page 95, use the Photoshop Elements Graphic Pen filter, which will make your photographs look like drawings. If, like me, you've always wanted to draw but never had the patience to learn, you will enjoy playing with this filter. You may have to experiment with a couple of images before you find one that really works well as a sketch, but choosing images that have strong lines and shapes is a good place to start.

Step 1: Make a duplicate copy of your original image and use the Levels adjustment tool (Enhance > Adjust Lighting > Levels) to boost the contrast. Make sure that your foreground color is set to black by clicking on the Set Default Colors button at the very bottom of the Toolbox.

Step 2: Go to Filter > Sketch > Graphic Pen. A new screen will appear. In the bottom left-hand corner, you will see a box with a percentage number. Open this box and select Fit on Screen. This will allow you to see the whole image as you experiment with different settings. For my example, I used 15 as my Stroke Length and 50 for my Light/Dark Balance. Experiment with these settings and see what works best for your image. I set Stroke Direction to Right Diagonal, clicked OK, and there was my sketch.

Step 3: As a final step, I selected Auto Levels to heighten the contrast so that the black would print as true black.

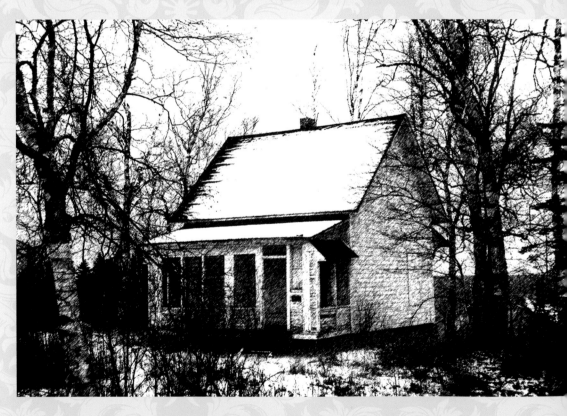

As in a mirror, the responsive observer will discover not only the artist's reflection in his work, but his own image as well. In this way, we share our findings with each other, communicate and fill a deep human need.
—Ruth Bernhard

EXPLORATION 9

Mirroring the World

One bright winter morning, I was looking out my studio door and I noticed that the holiday baubles that hung on the tree outside were reflecting my studio back to me. Standing behind my studio door with my zoom lens, I managed to zoom in close enough so that I could see my studio clearly reflected in one of the baubles. If you are shooting a reflection and don't want to be in the photograph, I have found that mirrors and other non-rounded, reflective surfaces usually allow you to exclude yourself and your camera if you simply stand off to one side as you make your photograph. With the rounded bauble, however, I had to hide behind my studio door while taking the shot.

In 1978, an exhibition of photography entitled "Mirrors and Windows" was held at the Museum of Modern Art in New York. The suggestion was that all photographs are either mirrors, which tell us tell us more about the inner world of the photographer, or windows, which tell us more about the world the photographer sees.

Photographing with a mirror as a reflective tool is a wonderful way to see things differently. Things are reflected back to you that you would not see otherwise. You literally see things in a new light. The images you create with a mirror can be very unique and can have people really looking at your images as they try and work out what you did to create them. You can't always make out which is the reflection and which is the "real" thing!

Find a mirror and place it where you think it will give an interesting reflection. Walk from one side of the mirror to the other. Note how the reflection changes as you move. Each step creates a new image. Try using a round mirror, a square mirror, or a broken mirror. I particularly like broken bits that have odd shaped edges (but be careful not to cut yourself on those edges!). Take photographs of what you see reflected in the mirror. Make sure the mirror is clean so you don't get a spot or streak in the middle of your image. I do not recommend using a flash, as it can create spots of light on your reflected image.

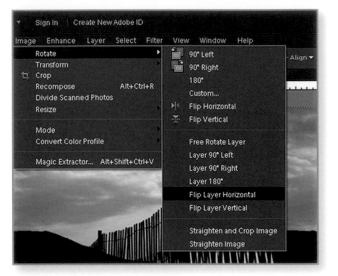

Figure 1

Figure 2

Creating Mirror-Image Effects

This is such an easy way to make a simple photograph look magical. Seeing your images mirrored highlights much you may not have noticed about them before, especially what is happening around the edges of your images. Play and experiment. You are creating your own unique designs.

Step 1: Decide on the finished size you would like your image to be. One of the standard print sizes is probably easiest. Open a new Photoshop document that is the final image size you have selected.

Step 2: Choose an image that you wish to use for the mirror-reflection effect and resize it to be half the width and half the height of the finished image size you decided upon. This means it will take up one quarter of your document size. Make sure that the resolution of both your image and the document you created in Step 1 is set to 300 ppi.

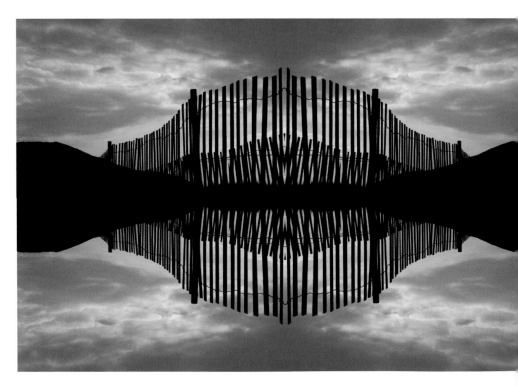

Figure 3

Step 3: Use the Move tool to drag your image onto the Photoshop document, placing it in the top left-hand corner of the document.

Step 4: Make a second layer of this image by going to Layer > Duplicate Layer and move the new layer to the top right-hand corner of your document. Then, go to Image > Rotate > Flip Layer Horizontal and your second layer will flip so that it becomes a mirror image of the first image (figure 1).

Step 5: Make your background layer invisible by clicking on the eye symbol to the left of the background layer. Merge the two visible layers of the image together by selecting one of them, clicking on the double arrow to the right of the Layers palette, and choosing the Merge Visible option (figure 2).

Step 6: Duplicate the merged layer using Layer > Duplicate Layer and move this layer to the bottom half of the document. Then, flip this duplicate layer using Image > Rotate > Flip Layer Vertical (figure 3) and merge all the image layers.

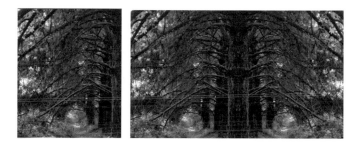

Below: By continuing to make duplicate layers and moving them to extend the original image, you can make a mosaic pattern, which could be printed out on your computer and used as wrapping paper for small gifts.

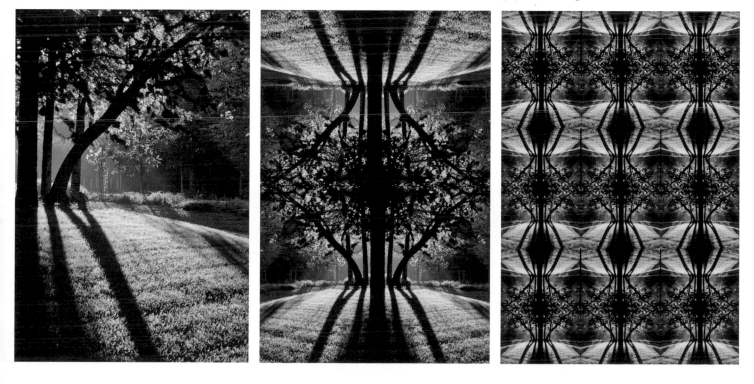

{ PHOTOGRAPHIC INSIGHT }

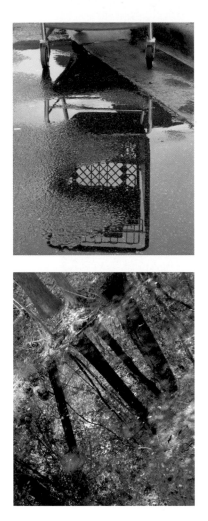

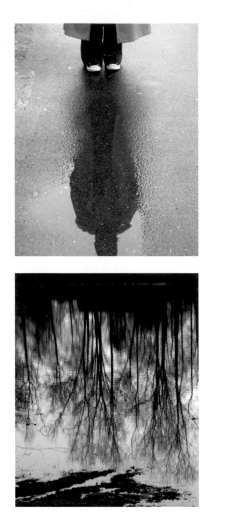

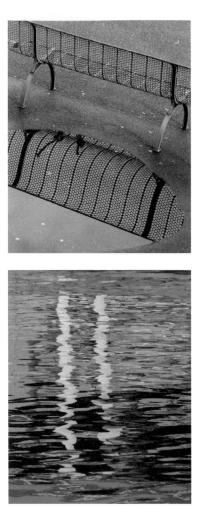

EXPLORATION 11
Reflecting on the Image Within

Even without mirrors, reflections are every-where. Water reflects, windows reflect—any smooth, shiny surfaces will cause reflections. Take your camera on an outing after a rainstorm and look in the puddles you pass to discover interesting reflections.

What I love about reflections is that nothing is exactly what it seems to be. Photographing a reflection can make something ordinary take on an artistic or abstract form. Reflections stimulate both the mind and the eye. They encourage you to engage in seeing in a different way. Images in water on a still day can create such perfect reflections that you do not know which parts of the image are real and which are reflected. On other days, the water moves and distorts the reflection, creating interesting abstract images.

Look for reflections all around you. They are everywhere. Document them with your camera. Find items that are reflective and photograph what is reflected in them. Instead of looking at a window, look to see what is reflected in it.

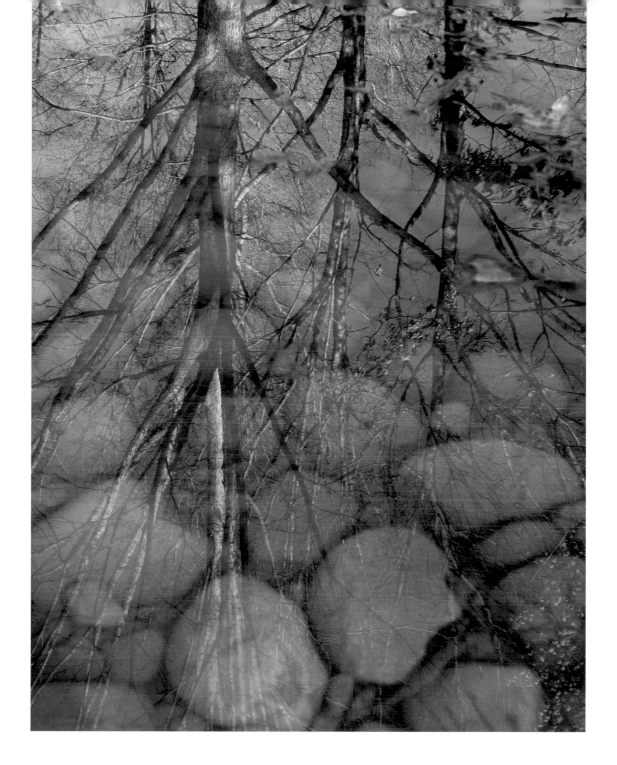

When you gaze at something, you bring it inside you. When you really look deeply at something, it becomes part of you.
—John O'Donohue

{ PHOTOGRAPHIC INSIGHT }

The moment
one gives
close
attention to
anything, even a
blade of grass,
it becomes
a mysterious,
awesome,
indescribably
magnificent
world
in itself.

–Henry Miller

GETTING CLOSER

Life can be a little overwhelming at times and, often, the only way to handle it is to simplify and focus on doing one thing at a time. When we simplify, we can see what is most important and prioritize accordingly. The same principle applies to our photographs. By cropping or composing out unnecessary elements, we strengthen our images. It's like editing a story. Sometimes, it is the parts that are left out that make the story more interesting.

Photographs of just the parts tell a story, too. You don't have to photograph a whole object to understand something about it. Become aware of your distance from your subject. If you don't have a zoom lens (and even if you do), you can always move physically closer to get to know your subject. Finding a picture within the picture can give you a whole new perspective on the world around you. You will see details you had ignored, and everyday objects can take on an abstract fascination.

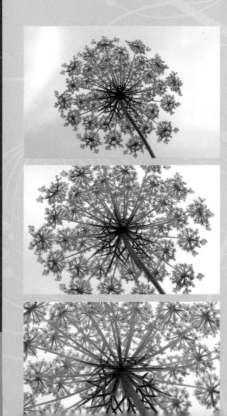

How close you can get to your subject will depend, in part, on your camera. You can get closer to objects that you cannot physically touch by using a zoom lens if you have one. However, if you love close-up photography, having a DSLR and a macro lens can make a world of difference and is well worth the investment. If you have a point-and-shoot camera, you may be able to get better close-up photographs by setting your camera to its macro setting, if available. It is usually indicated by a flower symbol. Play with your camera and see what settings give you the best close-up photographs. If your camera doesn't do well photographing close-ups, get as close as you can and take your shot. You can then crop and enlarge a portion of your image using Photoshop. Here are some things to remember when getting close to your subject:

1. Avoiding Motion Blur: You may need to use a tripod or another camera-stabilization method to get blur-free close-up images. Sharpness is important when trying to capture the intricacies of a small or detailed subject, and even the slightest camera movement can result in blurred images. When shooting outdoors, breezes can shake your subjects and jostle them out of the plane of focus. If your subject is portable, you could bring it inside and try setting up your shot there. Or, you could put up a screen so that the wind doesn't blow your subject around. A sheet of white foam board works well and doubles as a reflector.

2. Manual Focus: With my DSLR and macro lens, I get the best results by setting my camera on manual focus. I find it is easier to move myself and my camera to get perfect focus rather than relying on the camera's autofocus, which often has trouble locking onto the very small area of desired focus on close-up subjects.

3. Indoor Experimenting: Find a window in your home that has good light coming through it. Then, select some close-up subjects to experiment with and arrange them so that the natural light coming through the window falls on your desired plane of focus. This is a great way to learn about close-up photography, and there is no breeze to avoid!

EXPLORATION 1
Flower Power

There is so much beauty in flowers. Once you start photographing them, you can become enchanted by the perfect details, the color, and sometimes the minute life forms that live in them.

Get down to the level of the flower as if you were having a conversation with it. Get as close as your camera will allow. Look at the background. Is it simple and uncluttered? What color is it? Does the color enhance the flower or detract from it?

I love blurred backgrounds with images of flowers. Flowers are primarily about color and shape, and blurring the background—and even parts of the flower—allows us to focus on the color and form. If your camera has an Aperture Priority mode, this is a great time to use it. Set your camera to its smallest f/stop (which equates to its largest lens opening), such as f/2.8 or f/5.6. Zoom in as close as you can, being sure that you have some sort of camera support, such as a tripod or monopod, to avoid camera shake. Remember that the slightest breeze will move your subject and make it impossible to take a sharp photo, so you may want to have a windscreen handy, as well.

Photographing flowers can be done at a local botanical garden, in your garden, or in the garden of a friend. During spring and summer, I often buy plants for my garden and spend hours photographing them indoors before they are planted. I sometimes pick flowers from my garden and bring them into my studio just to photograph. You can even pick up a bunch of flowers from the supermarket and bring them home to photograph.

(hint)

I try never to photograph flowers when there is a large contrast of light and shadow, as the image I get will not be the one I saw with my eye. Cameras see light and shadow differently than the human eye does. If the flowers are outdoors, get a friend to hold a piece of white foam board over the flowers to shade them and avoid shadow contrast.

If we could see the miracle of a single flower clearly, our whole life would change. —Buddha

A WHOLE NEW PERSPECTIVE

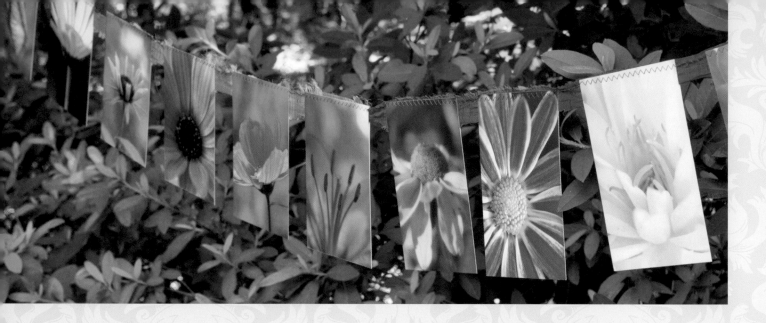

EXPLORATION 2
Prayer-Flag Banner

Collect together all your favorite flower photographs. If don't yet have enough photographs to choose from, go back to the previous exploration (on page 105) and spend a couple of hours photographing a bouquet of purchased flowers or a favorite local garden. Choose twelve or more of your flower photographs and print two 4 x 6-inch (10.2 x 15.2-cm) copies of each.

You could think of these photographs as flower prayers and the banner as a set of prayer flags. You could even add a word to each image as the prayer you would like the flowers to send out into the world. For example, if this were a banner for a sick friend, I might add the words: Heal, Peace, Beauty, Joy, and so on. Instead of sending a bouquet of flowers, the flower-prayer-flag banner can hang up in their room to remind them of your prayers and thoughts for their recovery. (Refer back to page 52 for more about how to add text to your images.)

Once you have selected your images, find a piece of ribbon (or tear a strip of cloth) long enough to attach all the photographs to, with additional length at the ends for the ties. In the example shown here, I used strips of recycled sari silk as my ribbon. Using double-sided tape, adhere two identical photos back to back. Leave a space at the top that is free of tape and wide enough for the ribbon to pass through. Slide the ribbon between the two identical photographs and sew it in place. Do this for each set of identical images, making sure to leave enough of the ribbon at each end of the banner to hang it up. The ribbon will also enable you to fasten the banner flags into a book, if you like, using a safety pin as the "binding" for the book.

Left: You can send, store, or display your banner in a different way by folding it into a book.

USING A SCANNER AS A CLOSE-UP CAMERA

We often forget that a flatbed scanner can be used like a camera. It can make unique, interesting, and sharply focused images of objects laid on it. You can scan three-dimensional objects in a scanner, although it will only capture a two-dimensional image; the scanner can only scan the part of the object that is directly against its document table. You can choose to leave the lid of the scanner open, or you can cover it with a box, the inside of which should be painted black. This acts as a cover over 3D objects to prevent unwanted light from being recorded with the scanned image.

For small, numerous, or messy items (such as buttons, flower seeds, or half a tomato) you can use a see-through tray or a sheet of acetate for easy setup, cleanup, and to protect the scanner glass. Scanning is perfect for objects that might be too small to photograph well, or where you want every part of the object to be in sharp focus. If you are planning to enlarge a scan of a very small object, be sure that you scan the object at a high resolution.

The image of the shells at left was made with a scanner, while the image above was made with a camera. Notice how they each evoke a different feeling about the subject.

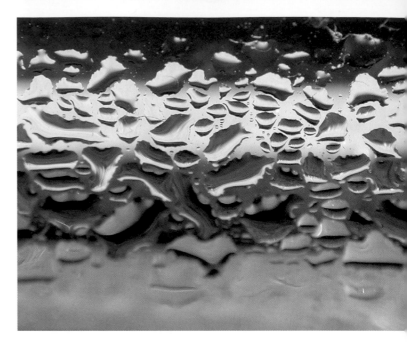

EXPLORATION 3
Abstract Photography

Ordinary things take on different dimensions when we focus on the details or photograph from unusual angles to highlight shapes and lines, or color, pattern, and texture. The resulting images may not remind you (or the viewer) of anything you know, but it will engage your brain as you try to make sense of what you are seeing. Viewing abstract imagery engages our vision in a different way. I believe our creativity is expanded when we see things we have to think about, without knowing exactly what they are.

Take the opportunity to focus on things that draw you in, that make no sense as conventional photographs, but that speak to you through their shape, color, pattern, or some other abstract element. Buildings—which are made up of angles, shapes, and lines—can make great abstract images if you focus in on a part of them that doesn't reveal the whole. One has to employ careful observation to discover an effective abstract image in the multi-faceted world we live in. Start looking at the environment around you and see what abstract elements of the objects and scenes around you appeal to your senses. Document them with your camera.

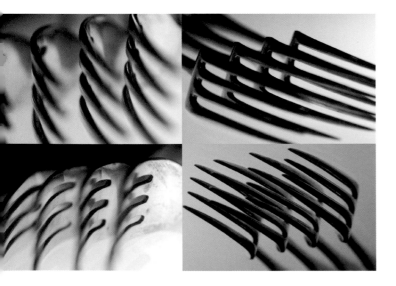

There is something about abstraction that is alluring. It forces the viewer to look afresh at the textures, colors, and patterns of our world.
—David Ward

Left: Four ordinary forks take on abstract dimensions.

EXPLORATION 4

Abstract Photographs as Journal Covers

Enlarge an abstract photograph and use it as a journal cover. Decide on the size of the journal you wish to create and fold the image accordingly. Start by folding the bottom edge down approximately one inch (2.54 cm), as if you were making a seam. Decide on the height of your book and fold the top edge over to form the inside of the cover. Cut off any excess and glue the folded sections down in place.

You can then decide on the width of your book and fold the other ends of the cover over to suit the size you select. A 12 x 18 inch (30.6 x 45.7 cm) enlargement can make an interesting long, narrow book. You can also choose to fold over an additional section (as shown at right) so that your pages will be fully enclosed by the cover. I tore the edge of the paper to add some texture to my cover.

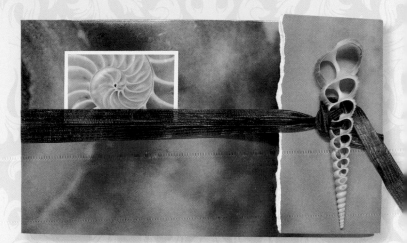

Left: I printed out a 12 x 18-inch (30.6 x 45.7-cm) enlargement and folded it to create the inside and outside cover.

Using paper of your choice, create pages to go inside the book. I like to use Fabriano Artistico hot press 140 lb (300 g) watercolor paper, but any paper will work. I sew down the fold of the pages with my sewing machine, but you can also do this by hand.

Insert the sewn pages into your journal cover and glue the first and last pages down on the journal cover. You could also sew the pages in. However, photo paper can be tough to sew through, so I prefer to glue in the pages.

Finally, top off your journal cover by adding another small image on the left-hand side. In this case, the abstract photograph I used for my full cover was a close-up of a shell. So, I chose a small shell image to add. Punch a couple of holes into your cover and use these to attach some interesting objects to the journal (a large button would work well), or just attach ribbons to tie the book closed.

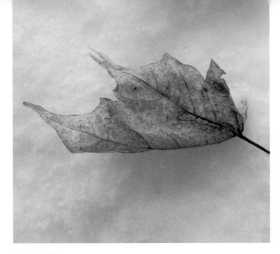

Original image

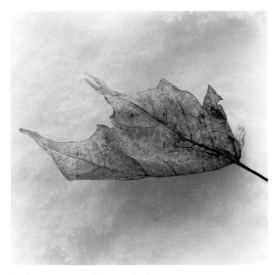

Light vignetting effect applied

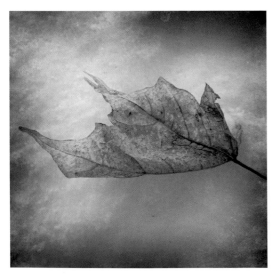

Dark vignetting effect applied

EXPLORATION 5

Vignetting Filter Effects

Traditionally, vignetting was the term used to describe the loss of clarity that could occur at the edges of an image due to poor lens design. However, this effect has an artistic element to it that many photographers find appealing. Vignetting can create a subtle framing within your image that draws the viewer's eye to the center of the photograph. Some software filters mimic the vignetting effect that "toy" cameras (such pinhole or Holga cameras) are notorious for.

The quickest way to add a vignette to your images is to use Filter > Correct Camera Distortion. Once you've navigated to this selection, on the right side of the screen, you will see a Vignette option. By moving the Amount and Midpoint sliders, you can either darken or lighten the areas just around the edge or more.

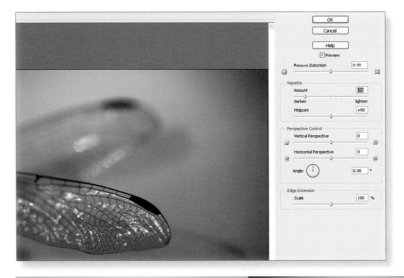

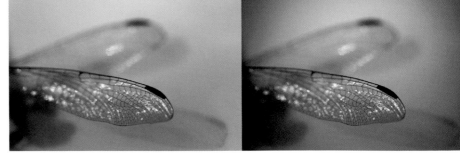

Original image Camera Distortion vignetting applied

EXPLORATION 6
Creating Your Own Vignetting Effects

If you want to have more control than most automated software filters offer over the degree of vignetting and where it occurs in your image, you may want to try to simulate the effect yourself.

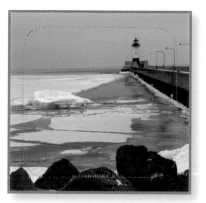

Figure 1

Step 1: Open the image you wish to work with and click on the Selection Marquee tool. When you do this, you will see the Feather box appear at the top of the page. Feathering softens the edges of your selection. If you don't feather your selection at all, you will get a solid, dark border around your image instead of a vignetting effect. Experiment to find out how much feathering you prefer. I find that 150 – 250 pixels is usually a good choice, but this will also depend on the size of your photograph. The smaller the photograph, the smaller the number of pixels required. When you enter a feathering amount, the square Selection Marquee tool will show rounded corners (figure 1).

Step 2: Select the area you want to frame with the vignetting effect, then go to Select > Inverse. This will select the outside border section of the image.

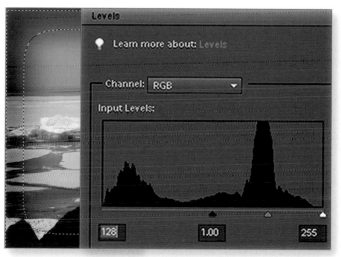

Figure 2

Step 3: Next, go to Enhance > Adjust Lighting > Levels and move the black triangle under the histogram towards the right if you want to create dark vignetting (figure 2) or towards the left if you want light vignetting. (You can also use the Hue/Saturation command to achieve this effect by moving the Lightness slider all the way to the left or the right.) Provided you have the Preview box checked, you will be able to see the effect the sliders have on your image and apply exactly the degree of vignetting that most appeals to you. When the effect looks as you want it to, click OK. Deselect the selection using the shortcut Control+D and your personalized vignetting effect is complete.

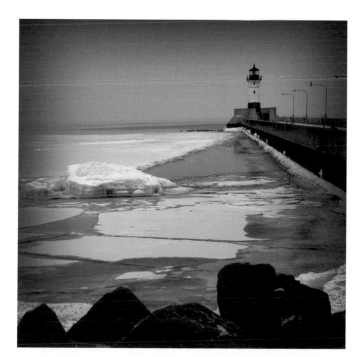

{ A WHOLE NEW PERSPECTIVE }

The job of the artist is always to deepen the mystery.

—Francis Bacon

SEEING DEEPLY

For me, "the mystery" is the day to day adventure of living life; having no idea what unexpected surprises the journey will hold allows me to be present to what is happening now, knowing that each moment can never be experienced again. Ralph Waldo Emerson puts it this way: "Each moment of the year has its own beauty … a picture which was never before and shall never be seen again." How can we convey the inexplicable nature of life in the images we create? How can we do so in such a way that it represents our own personal sense of what life is about?

I consider photography to be a spiritual practice. It encourages me to be attentive, to listen, to make meaning, to make connections, to cultivate wonder and gratitude, and, above all, to create. Our creative acts are gifts to ourselves and others. Our camera gives us a means to record the movement of a leaf in the breeze, the sunlight as it catches the water, every small and miraculous detail of the world around us. The camera lens often reveals to us the mystery that the human eye alone can't see.

Photographer Harold Feinstein says that one of his main ways of connecting with his subjects is through a prayer of gratitude for the beauty of what he is seeing, and for the eyes to see it. This deep seeing and gratitude can be sensed in the images he creates. We can find the sacred in our daily life by looking through eyes of gratitude. You can find this sense of gratitude and wonder in nature, and if you have ever been on a pilgrimage to a sacred place, you may also recognize that same feeling of awe that certain places and creations awaken in us.

We can add a sense of the unknown to our photographs by taking them at certain times of day and in certain weather. Morning mist can add mystery to our images, as can lights at nighttime. Certain colors have a more mysterious feel about them, and soft light can fill us with a sense of peace. Imaging software also offers many ways of altering our images to deepen the sense of mystery, such as softening or blurring them.

Top: Original image
Bottom: Soft-focus effect applied

Photography deals exquisitely with appearances, but nothing is what it appears to be. —Duane Michals

EMBRACE THE BLUR

We think of photography as reflecting reality and are, therefore, encouraged to create photographs that are perfectly in focus. But blur is a part of our reality. We don't see the world around us in a constant state of sharp focus. We might see a streak of color as a bird flies past, or turn our head quickly and merely register a blur of color on a building.

Using blur as a visual element in your images can convey a feeling of motion. To create this effect, place your camera on a tripod and pan it smoothly during the exposure, following the direction of the movement. This will keep your subject in acceptable focus but create a streaked blur behind it, giving the impression of motion. You may have to experiment a little to get the right movement of the camera to achieve an effect that you like.

Another way I add blur to my images is simply to switch my camera to Manual focus and unfocus the lens a little. I love the way lights are translated with this technique. They blur into circular orbs that add a mystical element to the scene.

{ AT YOUR COMPUTER }

EXPLORATION 1
Soft Focus

Adding a soft-focus effect to an image gives it an ephemeral, dreamy look. This effect can turn an ordinary photograph into a magical one. I also use this effect when I am disappointed in a photograph because I remembered the scene as far more beautiful than the photograph shows.

Step 1: Open your photograph and create a duplicate layer (Layer > Duplicate Layer). Working on your duplicate layer, go to Filter > Blur > Gaussian Blur and set your Radius to 15 pixels. Make sure that the Preview box is checked so you can see the effect as you apply it. When you've achieved the desired look, click OK.

Step 2: Next, go to your Layers palette and reduce the opacity of the blurred layer to around 50% using the Opacity slider. This creates your soft-focus effect.

EXPLORATION 2

Zooming and Moving

As we've covered, you can always throw part of your image out of focus by using a very small aperture to limit depth of field, but you can also create blur by deliberately moving your camera as you take your photograph. In addition, if you have a zoom lens, you can try out the technique of zooming the camera lens in and out during your exposure. To achieve the most noticeable results, you will need to set your camera to a slow shutter speed, such as 1/15 second or slower. Zoom in or out as smoothly as possible while keeping your camera very still so that the center of your image stays reasonably sharp while you create a streaking effect around the edges. I recommend using a tripod.

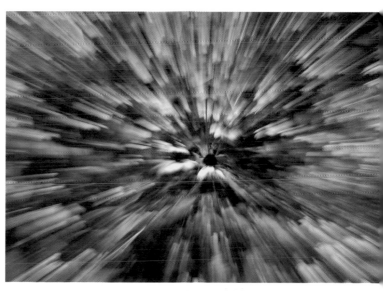

Yet another way to achieve a blurred look in your images is to try photographing through a textured surface of some sort. For example, I shot these photographs through a car windshield on a very rainy day. I love the blurry effect that the pouring rain gave to everything outside the car. The blur added to the essence of what was before me and showed me that the world isn't always as solid as it seems.

Above: Using a tripod or other image stabilization while zooming the lens during exposure will help to maintain a central, sharp element in your photo. Can you see the flower at the center of this image?

IN SEARCH OF THE MYSTERY

Mysteries lie all around us, even in the most familiar things, waiting only to be perceived.
—*Wynn Bullock*

EXPLORATION 3

Low-Light Photography

Low-light photographs often contain a certain dark, moody feeling. In creating them, we can use our images to convey a sense of mystery and atmosphere. Since we can only clearly see the parts of the scene that are illuminated by light, our imaginations are sparked.

One of the biggest technical considerations in creating low-light images is which ISO setting to use. This numeric value used to represent film speed but, in the world of digital photography, it represents how sensitively the camera responds to light. A higher ISO setting means that the camera will respond more sensitively, which means that faster shutter speeds can be used with less available light. With some cameras, shooting with high ISOs will result in grainier images, but this can also add to the mood of the photograph.

Most compact digital cameras will automatically adjust ISO when you are in a low-light situation, but they may also automatically fire the flash, which is not what you want when trying to create low-light imagery. Check your instruction manual to see how to disable the automatic flash and whether or not your camera enables you to select an ISO setting yourself. (DSLRs all allow you to manually set ISO.) In extremely low light, you will want to use an ISO setting of 1600 or greater (if available); for dimly lit scenes with slightly more light, you may be able to get away with using an ISO setting of 800.

The other option in low light is to keep your shutter open for longer. In order to maintain sharpness in your photo while you do this, you need a tripod. If you don't have a tripod, look for a wall or someplace you can sit your camera. You can even try to use your body for camera support. Lean against something if you can, spread your feet apart, keep your arms firmly against your sides, and press the shutter between breaths so that there is as little movement as possible during the exposure.

When photographing at night, you may notice that a certain transformation takes place. City scenes, for example, that might look a little drab or dirty during the day become vibrant with color at night, with trails of light created by cars and buses when shot with a slow shutter speed. Rain can also add to the interest of night scenes as you see lights and reflections in the puddles on what used to be just another dirty street.

(note) You won't be able to hold the camera still enough for sharp photographs without camera support—such as a tripod—when your shutter speed is under 1/60 second, so bear that in mind.

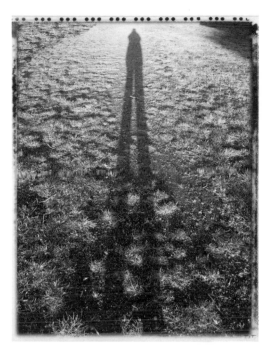

EXPLORATION 4
Photographing Light

Photography is all about light in its infinite variations. Consider all the ways the light from the sun changes throughout the day—and in different kinds of weather—and how changes in the light's color, direction, and intensity might affect the photographs you take. Also consider other light sources and types of light. Different sources of light have different color tones or "temperatures." Our eyes automatically adjust to these different colors, but our camera doesn't. You will see this clearly if you experiment with your camera's white balance settings.

Get to know how your camera responds to different lighting scenarios. Think of places where you can find interesting neon lights or spotlights. Look out for lights during the holiday season. Create your own lighting effects. Try blurring the lights. Let your camera record light in its myriad forms.

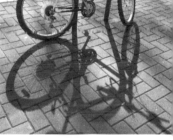

EXPLORATION 5
Light and Shadows

Shadows can be fascinating to photograph, and by photographing them, we become more aware of the light— what direction it's coming from, how it surrounds and affects a subject. By looking at the shadow of an object, we see it in terms of its lines and shapes rather than its color and purpose.

Shadows can add illusion and drama to ordinary scenes. Start looking around you to see how the light creates shadow patterns at different times of the day. Create your own shadow effects using a sun-filled window in your home; place an interesting object nearby in such a way that it casts a shadow or reflects a beam of light up onto the wall. Make sure your flash is turned off for these photographic experiments.

(hint) You can change the intensity of your camera's flash by covering it with a layer of tissue to create a more subtle lighting effect.

Make visible what, without you, might perhaps never have been seen. —*Robert Bresson*

{ IN SEARCH OF THE MYSTERY }

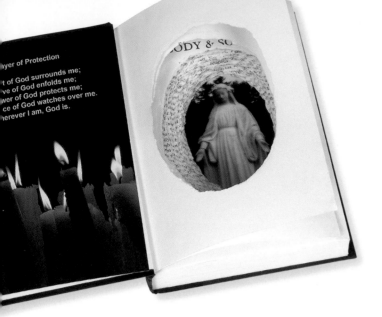

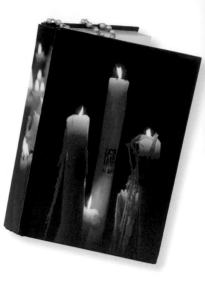

Paste the image you selected for the niche using either glue or double-sided tape, attaching it to the first intact page at the bottom. Be sure that the edges of your photograph do not show. Once the image is in place (as well as any images you want on the inside cover), you can glue the pages of the book into a block. Use Golden Soft Gel (Matte) or Regular Gel (Matte) to do this. Hold the pages firmly together (as they might be if the book were closed) but keep the cover open. Apply the medium around the

edges of the pages. Once the edges are covered, place a sheet of wax paper between the front cover and the first page, and another sheet underneath the book. Close the book and place something heavy on top of it. I usually put mine under a big pile of other books. When the book is dry, you can paint around the edges and add any photographs you selected for use on your front cover, back cover, and spine. A single photograph can span the entire cover or you can use smaller images.

E X P L O R A T I O N 6
Altered Books

This project requires the use of an old, hardcover book. You may already have one, or you can look at local thrift shops and used-book stores. Any size book will do.

The first step is to tear a niche out of the center of the book. Decide how big you want the niche to be, then draw the shape in pencil on the top page and tear a couple of pages as close as possible to that shape. If you hold the pages close to the area you want to tear, you have more control over where the tear goes.

As you tear deeper, the niche will automatically get smaller, which gives it a cave-like appearance. Once the niche is torn, size your photograph to fit. I usually place my photograph on the bottom of the niche so that it is supported by the remaining pages of the book. I also like to decorate the cover with my photographs, so measure the cover if you would like to do this.

(hint) I recommend ordering the photos you use here from a photo lab, as the strength of the photo paper they print on and the fact that the inks don't run (as inkjet prints might) is an advantage in this project.

EXPLORATION 7
Altar Candles

Use your photographs as candle decorations to inspire creativity, to honor someone, or to remind a friend that each day is special. I particularly like using the long-lasting candles that come in a clear, tall glass votive for this project.

You may have seen candles this size with pictures of Catholic saints on them, called Patron Saint candles. You can create your own Patron Saint, such as "Our Lady of Creative Inspiration" or "Our Lady of Abundant Chocolate." The secret is finding the appropriate photograph to match your imaginary saint.

Step 1: Measure your candle container, decide on the finished size of your sticker image, and select an image that is appropriate to the intention you envision for your candle.

Step 2: If you plan to add words below the image (as opposed to placing text within the image itself—see page 52), decide what color you want the background to be, as that color will be seen behind the text. Create a new Photoshop document that is the required size and background color.

Step 3: Resize the image you have selected to fit into your new document, insert any text you wish to add using the Text tool, then print your image out.

Step 4: Turn your print into a sticker using the Xyron machine and stick it on your glass candleholder. And don't feel limited to using the tall candles I suggest here; you can also use the small votive candleholders and decorate those in a similar way.

EXPLORATION 8
Photo Matchbox

I like to add a box of matches when I give a candle as a gift.

Measure the top of the matchbox you wish to cover, resize your image, print it out, and attach it to the matchbox with glue or by turning it into a sticker using the Xyron machine. I leave the sides of the matchbox uncovered so that they can still be used to light the matches. However, if you want to use the box for other purposes, you can attach a photograph that covers all its sides.

EXPLORATION 9
Seek the Image

We photographers are really seekers of beauty and light, which, I find, is one way to make sense of the mystery of life. Use your camera as a tool of discovery. It has been my experience that when you go out actively looking for something, you generally find it. Send yourself on a scavenger hunt. This is a playful way to open your eyes even wider, to notice every small detail in your surroundings. It is a great exercise to do with friends, as you can share your found images. Come up with your own unique list of items to seek out. You will find inspiration all around you!

8

Wabi suggests freshness and simplicity. Sabi describes a beauty that is burnished by age. … It's a zen notion; a fleeting, imperfect, accidental beauty— unpretentious, simple and intimate. Wabi-sabi is akin to the inherent beauty within, something you can't put your finger on … to open your senses to every detail, every glimmer, every breath of the breeze. That is all part of wabi-sabi.
—Daisuke Utagawe

WABI-SABI: SEEING BEAUTY IN THE OLD

We often pass right by old things, not noticing the beauty in the color of the tarnished rust or the peeling paint, only pausing to recognize beauty in things that are expensive or new. In much the same way, society emphasizes the recognition of beauty in a young person and doesn't focus on the amazing beauty of an older person whose experiences have etched themselves in wrinkles and wise eyes. The Japanese have a word for these aged things of overlooked and imperfect beauty. wabi-sabi. When we use wabi-sabi eyes, we start seeing the hidden beauty in imperfection and aging. This is a different way of looking.

Wabi-sabi is about those things we often pass by without seeing. It encompasses things that are on their journey to disintegration; it includes things that have been weathered and worn. Author Leonard Koren reminds us, "All things are impermanent. The inclination toward nothingness is unrelenting and universal. … The closer things get to nonexistence, the more exquisite and evocative they become. Consequently, to experience wabi-sabi means you have to slow way down, be patient, and look very closely." So, to begin to see with wabi-sabi eyes, start slowing down and paying attention to the small stuff. Look at commonplace things with a new interest. Look at details in the grain of old wood, the patterns of rust, the veins on an autumn leaf as it disintegrates.

Besides appreciating their beauty, another benefit of noticing deteriorating environments is that doing so may encourage us to do something to preserve or protect them. For example, taking photographs of a beautiful stretch of beach littered with plastic might encourage us to pick up the trash or use reusable drinking bottles. We might want to leave the place better than we found it rather than looking away in disgust.

EXPLORATION 1

Hidden Treasures of Imperfection

Old things seem to hold the energy of all those who held them or beheld them. They have a story, a history. They were once useful or meaningful, and now they have been left to disintegrate. They can remind us of the inevitable journey of our human body. Keep your eyes open for these hidden treasures of imperfection. Visit an old junkyard and look at the junk in a new way. Think about the "life" it had before it was discarded. Photograph these things in such a way that you focus on the beauty in their degeneration.

The eye altering, alters all. —William Blake

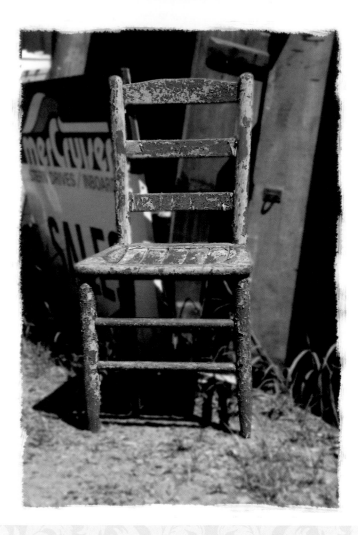

EXPLORATION 2

Junk-Treasures Tag Book

Once you have amassed a good collection of photographs of "junk treasures," print them out and turn your collection into a small tag book. This is a simple book to make and is perfect for collections, as it can easily be added to as you find more images. I chose to print my photographs out as small, 3 x 4-inch (7.6 x10.2-cm) images (half the size of a standard photograph). You can cover the backs of the images with paper or cardstock, if you wish, and write the stories—real or imagined—of the found objects on the backs of the photos.

Use a corner-rounding hole puncher to round off each corner of your photographs. Then, create a template onto which you use a regular hole puncher to punch out the top center of the photographs. Using a template will help to make sure that the hole is in the same place for each of the images so they line up. Then, you can easily attach a book ring to bind them together.

EXPLORATION 3

Antiquing Your Images

Photoshop Elements offers a lot of different options for adding a distressed or vintage look to your images. Most of these are easy to create and are a lot cleaner than creating vintage effects by hand (which can be fun, too—see page 126).
In particular, the Old Paper, Old Photo, and Sun Faded options, found in the Effects palette, can give an instant aged result.

Step 1: Make a duplicate layer of your photograph (Layer > Duplicate Layer). Then, go to the Effects palette and select Photo Effects > Old Paper, Photo Effects > Old Photo, or Layer Styles > Image Effects > Sun Faded. Try all three and see which results you prefer for your specific photo.

Step 2: Reduce the opacity of the top layer (which is the one with the effect applied to it) to between 50% and 70% so that some of the original color will show through and create a subtle, vintage look to your image.

Right: The Sun Faded effect creates an image that reminds me of those old photographs from the 60s that have discolored.

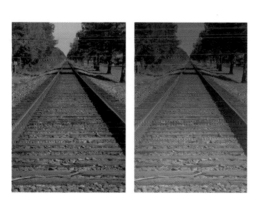

Below: Another very simple way to create an old-photo look is to reduce color saturation by going to Enhance > Adjust Color > Adjust Hue/Saturation and moving the Saturation slider left until you get an effect you like.

Above: I applied the Old Paper effect to this image and reduced the Opacity slider to 57%.

Above: I chose to use the Old Photo effect here, reducing the Opacity slider to 55%.

EXPLORATION 4
Vintage Paper Borders

By scanning the backs of old photographs and using them as borders to your new photographs, you can create an interesting antique paper look.

Step 1: Scan the back of an old photo and resize it (Image > Resize > Image Size) to be slightly larger that the new photo you want to place on it.

Step 2: Drag your new photograph onto the old-photo background, making sure that the old photo is larger than the new photo so it creates a border around the edge. If necessary, you can adjust the size of your top image by using Image > Resize > Scale.

Step 2 Alternate: Another option is to convert your new image to sepia and feather it before dragging it

onto the background. Convert it using the Tint Sepia selection in the Effects palette, select it using the Quick Selection tool, set the feathering to 5 – 10 pixels, and then drag it onto the scanned old photograph background. This will give you a blurred edge which, together with the sepia effect, will make the photograph look even older.

EXPLORATION 5

Adding Age with Grain and Texture

Adding digital grain, known as noise, can be another way to give an aged look or a feeling of deterioration to your image. Unwanted digital noise can occur when shooting with high ISOs or as a result of underexposure, but there are times when we can use this textured quality to our advantage to give a more artistic feel to an image. That said, it is always a good idea to obtain the best quality photo possible under the exposure conditions and add grain into the image later in a controlled way if you decide you want that effect.

Step 1: Open up your image, make a duplicate layer (Layer > Duplicate Layer), and convert that layer to black and white by going to Enhance > Convert to Black and White. (Remember, some programs may require you to start with a black-and-white image instead of creating a black-and-white layer—see the Hint on page 84.)

Step 2: Go to Filter > Noise > Add Noise. Set the Amount slider to between 30% and 50%. This will give you a strong effect. Click the circle beside Uniform (which determines the distribution of the grain) and check the box next to Monochromatic (so the noise is not colored). Click OK.

Step 3: You can fade the level of noise that is visible in your image by lowering the Opacity slider. If your original image is in color, you will see some of the color come through as you do this. I rather like this worn-color effect.

Step 4: Lastly, add a layer of scanned vintage paper using the Multiply blending mode and adjust the Opacity slider to get something even more textured and old-looking.

Above: I layered this hut image with scanned vintage paper and achieved the look I was going for using the Multiply blending mode.

{ ALL THINGS OLD AND BEAUTIFUL }

EXPLORATION 6

Sanding, Scratching, and Tearing

Sanding, scratching, and tearing your photographs can transform brand new images into ones that look as though they have just been found at the bottom of your grandmother's trunk in the attic. To sand a photograph, first place it in a container of water to wet it. Leave it in the water for a minute or more, then remove the photograph from the water and dry it lightly with a cloth. Next, using a sanding block or sandpaper, begin sanding over the image. Start off lightly so you can get an idea of the effect. Press down hard in any places where you want to completely obliterate the image. I like to sand vertically and horizontally across the image to create a cross-hatch effect. If you place a rough-textured surface underneath, you will create a design as you sand.

(note) Only photographs printed at a photo lab can be used for this project. It will not work with photographs printed on an inkjet printer.

Once you have completed sanding the photograph, rinse it again in water and leave it to dry. These photo-paper "pages" are sturdy and can easily be painted or glued on.

When I want a handmade border around a photograph, I scratch it with a sharp implement. Dip your finger (or a brush) in water and wipe the water over the area you plan to scratch. Dry it off and immediately scratch into the surface. The area that did not get wet will not take the scratching easily, so you can control the area you want to scratch. After scratching, you can use photo inks—or even acrylic paint—over the rough areas to give them some color.

Another way to add an interesting texture to the edge of a photograph is to tear it. You will notice that when you tear in a certain direction, the backing paper creates an interesting white edge around your image, which can act as a border. If you don't want this white edging, tear in the opposite direction.

Left: You can also use this technique to add a worn look to images that aren't throwaways by doing only a light sanding without wetting the photograph.

EXPLORATION 7

Accordion Book with Sanded Pages

Accordion books are my favorite easy books to make for photographs; they can double as quick displays on a sideboard, and they can also be made out of almost anything that you can fold. To decide on the size of the pages for your accordion book, place your photograph on the paper. Use a ruler and a craft knife to cut a couple of strips to the height you require. The number of strips you cut will depend on how long you want your book to be. To make the book longer, merely attach another strip, overlapping one of the folded pages.

For this project, I used a number of 5 x 7-inch (12.7 x 17.8-cm) "reject" photographs that I sanded to create textured background pages (see page 126 for detailed instructions). I then selected a number of photographs that I wanted to feature in my book and cut the main subjects out to use as collage elements. On some of the sanded pages, I added a little extra color using Caran D'Ache® water-soluble wax pastels. I then glued my cutout photographs onto these backgrounds and added some additional collage elements and random lines of poetry from an old poetry book. I also used the wax pastels to add a slight border around the edge of each page.

Once the pages were finished, I placed double-sided tape in the center of the backs of the pages to connect the "wrong" sides together. This kept the pages in place while I sandwiched a piece of cheesecloth between them. I sewed the fabric down along the edges of all the pages except the first and last, where I inserted lace at the edges. If you prefer not to sew, you can use double-sided tape or glue instead.

EXPLORATION 8

Creating Vintage Borders and Edges

There are so many options for creating unique borders and edges using Photoshop Elements. Here are just a few of my favorites.

Deckled Edges

Step 1: Enlarge your canvas by 10% around all the edges by going to Image > Resize > Canvas Size; select pixels rather than inches, adding 100 to 300 pixels to both the width and the height of the canvas (depending on your original image size). The color of the border depends on what color the canvas extension color is set to. You can choose this from the dropdown menu at the foot of the Canvas Size box. For a deckled edge, set this color to white.

Step 2: Using the Selection tool, create a selection just a bit inside your image.

Step 3: Go to Select > Inverse, which will select your border area.

Step 4: Go to Filter > Brush Strokes > Sprayed Strokes and play with the sliders until you get the effect you want. The values that work best will depend on the size of your photograph.

Emulsion Edges

Liquid emulsion is a form of alternate printing done by photographers to create interesting effects. With black paint and imaging software, you can create your own emulsion-type edges.

Step 1: Using a sheet of white paper and a bristly paintbrush, use black acrylic paint to create a shape with scratchy, bristly edges.

Step 2: Once the paint is completely dry, scan the painted paper into the computer. This will be your emulsion layer.

Step 3: Next, open the photograph you wish to frame with emulsion edges. Drag the painted emulsion layer on top of your image. (If it is not the same size as your image, resize it using Image > Resize > Scale before dragging it over.)

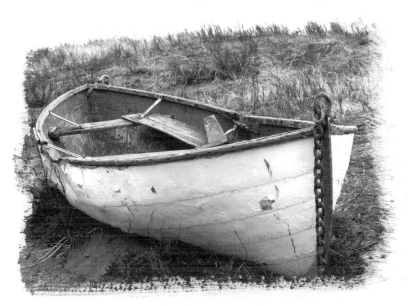

Step 4: Select the Screen blending mode.

Eraser-Tool Edges

Step 1: Open the image you wish to create an edge for and set your background color to the color you would like around your image using the Foreground and Background Color boxes at the bottom of the Toolbox. To select a color other than black or white, click on the Background color box and the Color Picker will appear, allowing you to select a new color.

Step 2: Select the Eraser tool and set it to a brush type that has a rough edge. For this example, I used one of the Thick Heavy brushes. Set the pixel size of the brush depending on the size of your image. The larger your image, the larger the pixel size of your brush needs to be to ensure it will be visible.

Right: If you prefer a black emulsion-type edge, invert the painted emulsion layer (Filter > Adjustments > Invert) before dragging it onto your image. Then, select the Multiply blending mode.

Step 3: Using the Eraser tool, start erasing away the outer edge of your image. This will create a rough edge around your image, with the background color you selected in Step 1 showing through underneath.

EXPLORATION 9
Recycling Old Negatives

I have piles of old film negatives, as I'm sure many of you do, too. Being able to find new uses for old things, especially in an artful way, is a great way to use your creativity. Old negatives can make for especially interesting border frames for small, contact-sheet-size photographs. Here is how it's done.

Step 1: First, wet the negatives and dry them.

Step 2: Use a sharp implement (like a flat-bladed knife) to scratch some of the emulsion away from the center of the negative to form a border of emulsion around the edge. It comes off easily as long as you scrape the back of the negative strip (identified by reversed numbers along the edge).

Step 3: Size some photographs to fit neatly behind the filmstrip. You can use the command Print > Contact Sheet to get the right size.

Step 4: Print out your images and use gel medium to attach them to the back of the negative strip so they peek through the scratched-off emulsion areas.

Step 5: To display these, I used a thin strip of wood. I attached the filmstrip-framed images using gel medium, then used rubber stamps to add a quote. I drilled holes in the top of the wood to hang it.

EXPLORATION 10
Faux Tintypes

Tintypes are photographs made by developing an image with a photographic emulsion on iron metal—a technique that was very popular in the 1850s. An easy way to produce a faux tintype is by using ArtEmboss® metal sheets and a transparency sheet that has been printed with your image. Size your image to fit your project, print it out on a transparency sheet, and run the transparency through the Xyron machine. Adhere your sticky transparency to the metal sheet, cut it to size, and you have your vintage-tintype look for your photographs.

For this project, I used vintage fabric and lace together with old photographs of my grandmother, which I printed directly onto InkJetPrinting Cotton by Jacquard®.

{ AT YOUR ART TABLE }

EXPLORATION 11

Antique Fabric Book

Printing your images on fabric allows you to create personalized pillowcases, journal covers, or fabric books, as illustrated here—creations that go beyond the limitations of paper prints. To get the clearest possible image on fabric with the least amount of work, I have found that InkJetPrinting Cotton by Jacquard® works well. It comes in silk as well as cotton. The fabric already has a paper backing and is a standard letter size, so it feeds through an inkjet printer very easily. Once your photos are printed, you merely peel the paper backing from the fabric and it is ready to use. If you plan to wash the item, you need to allow the ink to dry for 24 hours before washing in cold water.

Step 1: Decide on the size of your finished book (when laid open) and cut all your fabric or lace pages to this size.

Step 2: Next, resize the images you have selected to fit the pages you cut out.

Step 3: Print your images onto your inkjet fabric, cut them out, and sew them onto your base pages.

(hint) Every printer will respond differently to printing on fabric. You may have to try a couple of different printer settings before finding the one that works best.

Step 4: When all of the pages are complete, lay them on top of each other in the order you would like them to be seen and sew down the middle of the fabric to form the binding of the book. The number of fabric pages in the book is up to you, but if you plan to bind the book with a sewing machine, make sure it is not too thick.

Step 5: Add embellishments, such as buttons and lace, to the front of the book.

PHOTOGRAPHY AS MEDITATION

'In this twentieth century, to stop rushing around, to sit quietly on the grass, to switch off the world and come back to the earth, to allow the eye to see a willow, a bush, a cloud, a leaf, is 'an unforgettable experience.'
—Frederick Franck

SEEING WITH SLOW EYES

How long does it take us to see something? For so long, I lived my life at the fastest pace I could. I thought juggling as many balls as possible made me a productive—and therefore valuable—member of society. However, I've learned that life is not about *doing* without really *being* there; it is more about those moments that we are truly present. Yes, we can be seen to be terribly productive, but then, as T.S. Eliot says, "Where is the life we have lost in the living?" When was the last time you sat and gazed at something, completely intent on that one thing, for an hour? Do you think it would change the way you see the object? Do you think it might change you? How might it change things?

The well-known photographer and teacher, Minor White, tells us that he sought out solitary areas, such as deserts or mountains, to do his photography. Or, if he was photographing a small item, he just looked for a place where he could be alone. He said, "I'm waiting. I'm listening. I go to those places and get myself ready through meditation. Through being quiet and willing to wait, I can begin to see the inner man and the essence of the subject in front of me."

To understand this more fully, find an item around your house such as a shell, a stone, anything small. Look deeply at this item. Then close your eyes and focus on your breathing for five minutes. Open your eyes and focus again on your item. Feel yourself entering into a dialog with it; you are communicating with it and it is communicating back to you. Make it the center of your universe for five minutes. You will find that you see the item in a different way.

You could also take ten minutes to walk around outside. Use all your senses to record your experience: the smell of the season, the sounds, light and shadow, the air on your skin. Imagine that you are seeing the world for the first time. What catches your attention? Take this level of sensing into your photography. Your senses can feed your imagination and open you up to a new way of seeing.

If you are a poet, you will see that there is a cloud in this sheet of paper. Without a cloud, there will be no rain; without rain, the trees cannot grow; and without trees, we cannot make paper. —Thich Nhat Hanh

EXPLORATION 1
Slow Photography

For this exercise, I had in mind that I would ask you to sit with an object for an hour doing nothing but gazing at it. But, I knew I, myself, couldn't do that. My mind would start telling me that I was wasting time, that I should be cleaning the house or answering emails. So, I decided to make it a little easier. Put on music that speaks to you, perhaps something without words to distract you and loud enough to drown out any other noises. Then, take your camera and sit in front of an object you have decided you want to photograph.

Take a photograph of this object every five minutes for an hour (a total of 12 images). In between, just look at the object, contemplate it, and listen to the music.

Think about where the object came from, how many hands it passed through to get to you, whether it has been touched by the sun or the earth, by ocean, river, or stream. Think about its symbolic meaning. Consider this object in the light of the above quote by Thich Nhat Hanh, bearing in mind that photographers are visual poets.

Once you have your 12 photographs, print them out and look at them. Did anything happen as you looked at your object? The patience required to sit mindfully with the object you are photographing will be rewarded as you start noticing subtle changes in the way you see it as time passes. Making photographs in a mindful way awakens our senses and our awareness to the world around us.

EXPLORATION 2
One Place, One Hour

This is an exercise for one of those days when there is snow outdoors, or it is pouring with rain, or too humid and hot to feel comfortable outside. Close yourself in one room in your house and take at least 50 photographs of that room and its contents. Look at everything as if you were seeing it for the first time, or the last time. In fact, everything you see will never be seen again in exactly the same way as you are seeing it now. We spend a lot of time acquiring things, but little time with them. See what you discover about this room that you never knew. Remember to explore the room with all your senses. This is not about taking "good" photographs; it is about allowing a dialog to develop between you, your camera, and your surroundings.

EXPLORATION 3
Revealing Time

As photographers, we can stop the world for an instant. We can record a moment in time, one that will never be experienced again. We can show the movement of time with both blur and the freezing of a moment. It is fascinating how we can record time in two such different ways—one with a subject that doesn't move (such as a building) creating the backdrop for the flow of time (like the people walking in and out of the building), the other with a subject (such as the ocean) that doesn't stop moving, resulting in photographs taken seconds apart showing different instances of time. As we see time moving, we recognize the impermanence of everything.

Think of all the ways you can record the movement of time. Place your camera on stable support, such as on a tripod or a ledge, and capture the movement of people in and around a given space. Almost any stable surface will do, so long as your camera doesn't move.

People who are standing still will be in focus and those who are moving will look like ghost shadows, almost as if they are not in the image.

Photograph something that never stays the same, such as the seashore and the waves. You will never be able to duplicate a photograph. Every image will be different. The difference may be subtle, but it will be there. Write a word in the sand and wait for the tide to slowly wash it away, photographing it in its various states of disintegration.

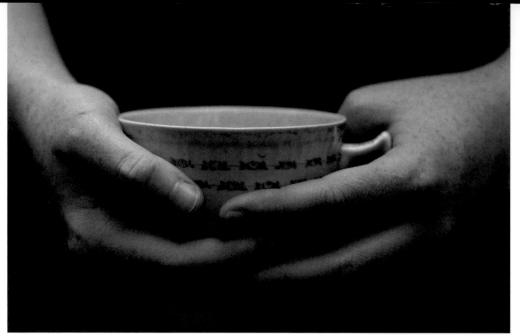

EXPLORATION 4

Quiet Photography

What would a "quiet" photograph look like? How can we translate the quality of "stillness" into our images? What would a "peaceful" photograph look like? Spend time making photographs that distill the essence of the idea of peace and calm.

Bear in mind that finding ways to photograph these qualities does not necessarily mean being in a place where there is no noise. Often, you can be in the middle of noise and bustle yet still find an oasis of peace. Look around. Can you find a visual symbol of peace exactly where you are? If you can't, think of where you might find one. It might be closer than you think.

Spend an hour or a day making "quiet photographs." Consider colors that feel tranquil. Go to a place that feels peaceful. Notice how you feel at the end of the time. Are you moving more slowly? Are you calmer, more relaxed? Perhaps by looking for visual cues to peace and calm, you can really find it.

EXPLORATION 5

The Language of Simplicity

Simplicity in your images is a distinct visual language. A photograph that contains only one element or one color may be sparse, but it communicates the essence of beauty. Look for an image that isolates a subject from the rush of life around it. You may have to move in closer to the object to let it really be seen. Let your photography become a mindful meditation so that you fully embrace your experience of seeing.

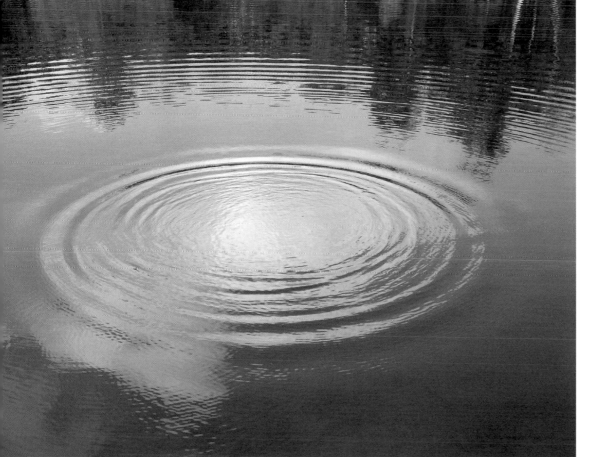

Even the simplest thing is as important as the things we consider important. I consider a fallen leaf as important as the Grand Canyon. It's all important; it's all connected. One couldn't be without the other.
—Ruth Bernhard

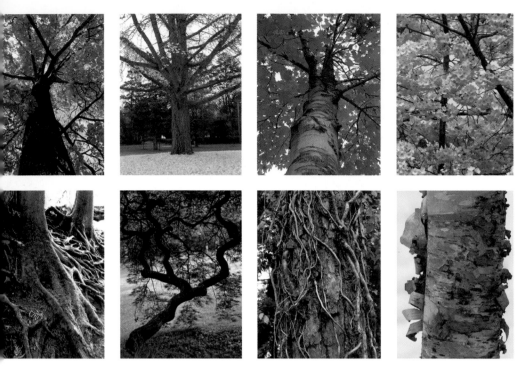

So much of life goes on while we are not looking. Everything around us has a secret life. Your camera can help you explore these secrets. Think of something in the world that you would like to gain a more intimate knowledge of. Read up on the subject so you know what to look out for. Two things that intrigue me are trees and water, mostly because they are continually changing and, therefore, always inviting me to look closely at them and explore them further.

To see we must forget the name of the thing we are looking at. —Claude Monet

EXPLORATION 6
Getting to Know a Tree

{ WITH YOUR CAMERA }

There are so many ways to photograph a single tree, and each tree is unique and changes every day. Trees are homes to animals; they offer protection from the wind and the sun; they are places where one can hide in the branches; they give us privacy. Look at trees and see them in their many different forms. Look at the shapes of their leaves, the texture of their trunks, the arrangement of their branches.

Remember to turn your camera upward when you are around trees. Photographing trees from this angle shows the pattern that the top branches make against the sky, and can exaggerate the trunk of the tree. Try this in different seasons. A forest in winter looks very different from a forest in fall or summer. Snow simplifies the landscape and allows us to focus on the line and shape of the tree. In fall, the tree is a mass of color that often hides the shape of the branches.

Find a tree close to where you live and take a photograph of it every day—or every week—for a year. Get to know the birds that live in the tree, the shadows that the tree makes, the shape of its leaves, how it looks in the rain, how it looks at night. Remember what American landscape architect Jens Jensen says about trees: "To understand and appreciate the message of an old oak means more for a good life than all the books of man."

It takes patience to really get to know anyone or anything. See this as a meditative exercise. If you don't yet have the patience for a tree, try a flower, as its life cycle is shorter and you can see it move from seed, to bud, to flower, to compost in a matter of weeks.

EXPLORATION 7
Tree Book

Create a book that contains images of trees in all their variations and at different times of the year. For this project, I used a cover from a vintage book, twigs and bark found in my yard, and twine

For the cover image, I took a photograph of a tree and sanded it using the technique detailed on page 126 to give it a distressed look. I then used a sharp tool to scratch the name of the book onto the photograph. I used a two-hole punch to make holes in the photographs, and tied the twine through them. I also punched matching holes in the spine of the book and tied the twine through these as well as tying it firmly around the twigs.

There is no such thing as taking too much time, because your soul is in that picture. —Ruth Bernhard

{ PHOTOGRAPHY AS MEDITATION }

EXPLORATION 8
Leaf Linocuts

A linocut is a design traditionally carved into linoleum or wood and used to stamp designs with ink, much in the same way as you would use a rubber stamp. The linocuts themselves have a very distinctive look, and that look can be reproduced using imaging software. Leaves scanned from my garden create wonderful linocuts. You can also use this technique with certain photographs. Not all photographs will work, however, so you will have to experiment to find out which kinds of images work best.

Step 1: For my leaf method, the first step is to find an interesting leaf and scan it. Once you have your image file, open it in Photoshop Elements and make a duplicate layer (Layer > Duplicate Layer).

Step 2: Next, go to Enhance > Unsharp Mask. Set the Amount to 500% and the Threshold to 0. You will need to determine what Radius setting gives you the effect you want. The higher the radius value, the less fine the linocut effect. I recommend starting with a radius value of 8 and adjusting from there to see what you like best.

Step 3: Then go to Filter > Blur > Gaussian Blur and set the Radius at about one quarter of the value you used in the previous step (i.e., if your Unsharp Mask Radius was 8, your Gaussian Blur Radius will be 2).

Step 4: Repeat the Enhance > Unsharp Mask step using the same Radius you selected in Step 2.

Step 5: Finally, go to Filter > Adjustments > Threshold and adjust the Threshold level until you get an image that you like. It will now be black and white and look like a linocut.

To try out different linocut effects, go to your blending modes and try a couple of them. My favorites for this are Multiply and Lighten. Applying a blending mode will bring up the underlying color of your original scanned leaf. You can also invert your linocut by going to Filter > Adjustments > Invert.

(hint) Make notes as you go so you can remember the different radius settings you used to create different effects.

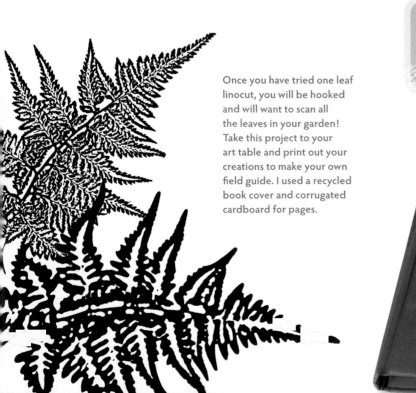

Once you have tried one leaf linocut, you will be hooked and will want to scan all the leaves in your garden! Take this project to your art table and print out your creations to make your own field guide. I used a recycled book cover and corrugated cardboard for pages.

EXPLORATION 9

The Secret Life of Water

How many different ways can you photograph water? Water lives in so many different disguises, from flowing rivers, to steam, to ice, to rain, and beyond. To capture the visual experience of water is an interesting challenge, as water is so much more than just a wet substance; light and reflection can also play a part in our images of water. We see flow and movement, even pattern and shape. Start looking at water more mindfully and you will see more than an expression of "wet." See how many ways you can record it. You could spend a lifetime photographing water and still be recording it in different ways.

EXPLORATION 10

Studio Water Droplets

Step 1: Paint the inside of a cardboard box black.

Step 2: Spray Rain-X® Original Glass Treatment™ onto a piece of glass that is large enough to cover the top of the cardboard box.

Step 3: Next, sprinkle a little water over the glass.

Step 4: Put something bright into the black box. I have used a flower and also a votive candle. (If you use a candle, take care not to catch the box on fire, and don't leave it there for too long, as the glass will get very hot.)

Step 5: The object in the box will be reflected in the water droplets. You will get some very interesting effects. Photograph the droplets from all angles and be awed by the ability of water to transform into something magical.

In the same way that water is not an imperfect mirror, but rather a live interpretation of its surroundings, so photography is not an imperfect record, but a continual, conscious appraisal of all that passes before its surface. —Tom Ang

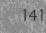

PHOTOGRAPHY AS MEDITATION

EXPLORATION 11
Visual Poetry

I love poetry and often wish I could find the words to express myself as eloquently as Mary Oliver or David Whyte. Some of us express ourselves more easily in images. Images can be metaphors and symbols of meaning in the same way an evocative word can remind us of a memory.

Find a favorite poem that speaks to you on a deep level and memorize it. Then, take it line by line and find an image that resonates with each thought expressed in the poem. This exercise helps you to slow down as you search for the perfect visual expression of the words in the poem. The photographs you take need not be literal interpretations of the poem, but should rather be visual representations of how the poem makes you feel.

IMAGE AS CREATIVE INSPIRATION

Let an image inspire you to write. Choose one of your favorite photographs. Sit with it quietly. Let your image inspire you to write a short story, a poem, or even a haiku.

A haiku is a form of Japanese poetry that consists of three lines. Traditionally the first line has five syllables, the second has seven syllables, and the third has five syllables. But focus more on the essence of a haiku—insight and simplicity—rather than feeling that you have to have the exact number of syllables. According to poet Ann Atwood, haiku "is the fusion of seeing and feeling." She explains that "all elaboration of ideas and descriptions has been eliminated so that this seeing-feeling can be instantly and spontaneously experienced." This seems similar to the experience of photographing, especially if one practices photography in an unhurried manner.

In becoming a photographer I am only changing mediums. The essential core of both verse and photography is poetry… —Minor White

EXPLORATION 12
Envisioning Gratitude

Every day offers us many things for which to be thankful. So often, we focus on what we don't have rather than what we do have. Let your camera be an instrument of gratitude. Use it to photograph any large or small thing in your daily life that you feel grateful for: a cup of tea, your warm bed, the sun shining through the window, clean laundry, your child's smile, a precious pet, a flower, a red strawberry. We are surrounded by so much beauty and abundance.

EXPLORATION 13
Deck of Gratitude Cards

Print your images of gratitude out, sized to fit on a standard playing card. Glue them over the faces of the cards to create your own deck of Gratitude Cards. At the end of the year, you will be reminded of the many things you have to be grateful for. What a beautiful inheritance this could be to pass on to your family: a visual journal of gratitude.

The essence of all beautiful art, all great art, is gratitude.
—Friedrich Nietzsche